IMAGES
*of America*

# PAPILLION

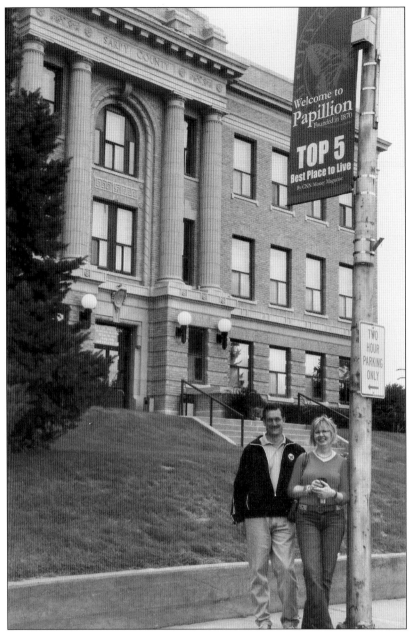

The 1923 Sarpy County Courthouse, now city hall, is the perfect backdrop for a photograph of Mayor David P. Black and his wife, Renee. Mayor Black's commitment to collaboration with the many qualified city managers, council members, and civic leaders makes it no secret why Papillion is a great American city. (Photograph by Steve and Bobbi Olson.)

ON THE COVER: In 1901, Louis Bostwick (left), a famous Omaha photographer, came to Papillion to show off his magnificent motorcar and received a welcoming handshake from Papillion mayor Charles Rosencranz. Charles Hagedorn and young Dave Rosencranz get a ride in a Locomobile (Locomotive automobile), which was manufactured in the United States from 1899 to about 1903 and sold for around $750. (Courtesy of the Sarpy County Historical Society.)

# IMAGES
## *of America*

# PAPILLION

Leah C. Hoins

ARCADIA
PUBLISHING

Published by Arcadia Publishing
Charleston, South Carolina

Printed in the United States of America

Library of Congress Control Number: 2011931580

For all general information, please contact Arcadia Publishing:
Telephone 843-853-2070
Fax 843-853-0044
E-mail sales@arcadiapublishing.com
For customer service and orders:
Toll-Free 1-888-313-2665

Visit us on the Internet at www.arcadiapublishing.com

*To my Daniel*
*The admiration of 10,000 could not compare to*
*the love I feel because you believe in me.*

# CONTENTS

# Acknowledgments

My love of history is directly related to the people whose lives make it interesting. I am not a historian who blankly assembles facts; I search for living connections, stories, and people whose accomplishments did not make the major history books.

This book is a mixed bag of historical fact, local lore, and family stories reflected in photographic images. Some of the information will be as a dot at the end of a sentence, while other details will create question and open conversations. My greatest desire is that people will enjoy observing the pioneer spirit of Papillion from this collection of images and appreciate that it is alive and well.

I want to thank my husband, Daniel, and our children, Zachariah and Casey, Miriah and Scott, and Gabriel. My dream is that our legacy will be reflected in our love of God and people. I also thank my parents, Jim and Shirley Burnette, for teaching me that the miracle of life is not in perfection but redemption.

Special acknowledgments go to my friends at the Papillion Area Historical Society (PAHS) who allowed me unrestricted use of photographs and research materials. I also applaud individual contributors and representatives of local organizations, churches, and businesses that were an important part of this project. Their names will appear as photograph credits throughout the book.

To the exceptional staff at the Sump Memorial Public Library, I offer my gratitude and beg forgiveness for wearing out the microfilm reader.

Ben Justman, the director of the Sarpy County Historical Society (SCHS), made an immeasurable contribution by allowing me access to the quality historical collections and research materials and photographic archives. The project would have been impossible without the society's cooperation.

I want to thank the Honorable Robert O'Neal, an unofficial ambassador of the city of Papillion, for bearing witness in the Introduction of what keeps a growing city a community with small-town values.

Special thanks go to my friend Sharon Ginger for bearing with my historical perspective on everything we discuss and to Deloris Wittmuss, who speaks a fluent language of community pride, which blows life into our past and hope into our future.

# INTRODUCTION

In 1970, as part of Papillion's centennial celebration, volunteers organized a pageant recounting the history of the community. The centerpiece of the finale was a song entitled "Papillion the Pride of the Prairie," written by the Reverend Don Marsh, a former pastor of St. Paul's Methodist Church. That pride in Papillion has been a hallmark of the community and its people since its inception. It translates into an intense sense of community and a passion by its citizens to make the city a better place to live.

Papillion is the kind of place where the best show in town on a crisp autumn Friday night is a football game at a packed stadium with our two high school teams battling for bragging rights for the next year; a Broadway musical under the summer stars at the new Sumptur Amphitheater, built with monies from local donors; or the annual June parade on Washington Street celebrating the city's roots and led by our local American Legion post.

Papillion is a happy combination of the descendants of our pioneer families, military families—some who are with us a few short years and others a lifetime—and scores of newcomers, who started arriving after World War II and keep on coming. It is a rich mix with a vibrant faith community, a strong sense of volunteerism, and a real dedication to children and young people, evidenced by our high-quality schools and youth activities.

The success of Papillion in 2011 did not occur by accident. It is because of the great pride of Papillion's forebears that a foundation was laid so that the people who followed in "Papio" could build the wonderful community we call home today. In this book, Leah Hoins has captured the best of who we were as a community and how it continues to influence the best of who we are and will be in the future.

—Bob O'Neal

Don Marsh, former pastor of St. Paul's United Methodist Church, wrote two songs that were included in Papillion's Centennial Celebration in 1970. The songs are an important reflection of the pride that grows in the hearts of those who call Papillion home.

"Papillion, The Pride of the Prairie"

Papillion, the Pride of the Prairie,
Your mem'ries are calling to me.
They cause me a moment to tarry,
The years in their fulness to see,

While down through the valley your waters are flowing.
Like time passing on through a prayer;
Papillion, the pride of the Prairie,
I hope you will always be there!

"The Papio Flutter-By Walk"

Here's the way to have a little fun, my friend;
Maybe it'll grow into a national trend;
Just turn a little twist, then you make a little Bend-
It's the Papio Flutter-By walk!

It's the groovy step that's a-takin' the town:
You wink at your honey and you shuffle around'.
One twinkie up and the other flappin' down-
It's the Papio Flutter-By walk!

Flip, flap, flip, like a butterfly wing;
Shuffle, shuffle, with a ring-a-ding-ding!
Everybody here just a-doin' his thing;
Flip! Shuffle! Everybody ruffle!

When you're havin' trouble and you're feelin' blue,
Take a little tip from you-know-who;
Soon you'll feel so good you won't believe you're you-
It's the Papio Flutter-By walk!

It's the Papio Flutter-By-
Butterfly, Flutter-By-
Papio Flutter-By walk!

# One

# THE BIRTH OF THE BUTTERFLY CITY
## PRIDE OF THE PAPILLION PIONEERS

Before the railroad connected the East and West Coasts across Nebraska or wagon trains trekked across ruddy trails, French fur traders canoed the "Big Muddy" Missouri River and began hunting the area now known as Sarpy County. They followed a creek that led them to a lush valley covered with wildflowers and milkweed, teeming with butterflies so profuse that one cried out in his native tongue, "Ah, papillon!," which over time was modified to Papillion. Soon after the area was discovered, it became home to a displaced tribe of Omaha Indians from the village of Ton Won Tonga near Homer, Nebraska. The teepee village thrived in the peaceful valley along the Papillion Creek until 1854, when the passage of the Kansas-Nebraska Act opened the territory to settlers.

A boost in Nebraska Territory population came with the newly constructed railroads and the passage of the Homestead Act of 1964, which provided 160 acres of land to qualified individuals willing to live on it for five years, with an enticing provision for immigrants who volunteered as soldiers in the Civil War. Veterans who were not yet citizens could deduct one year from the residency requirement of homesteaders for each year of service, making the prospects of pioneering even more beneficial. Gentlemen such as Louis Lesieur, Henry Fase, and William A. Bell profited from this advantage and mixed with others, like A.W. Clarke, H.A. Sander, and George M. Mullins, to establish a community as industrious as it was agricultural.

Papillion's population was a unique blend of immigrants from Germany, France, and England who meshed with those from New York, Pennsylvania, and Ohio. From this concoction of cultures, a village emerged with all the characteristics of the Wild West, and deep familial roots took hold of Midwest soil.

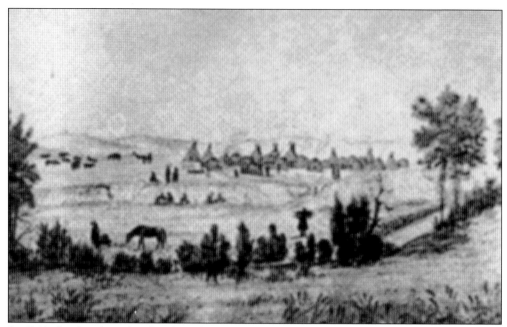

In 1844, the Omaha tribe abandoned the Ton Won Tonga (Big Valley) near Homer, Nebraska, and relocated to the Papillion Creek, which is where they established a teepee village eight miles west of Bellevue. In 1854, the Kansas-Nebraska Act was passed, opening the territory to white settlers. (Courtesy of Lee Brown.)

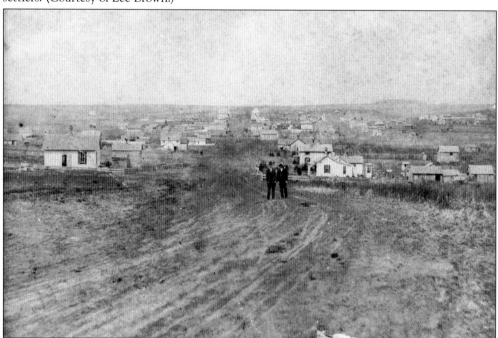

This important image of the prairie town of Papillion is not dated but is obviously from early in the town's history. The two gentlemen in the road are standing in the area of what is believed to be Hallack and Washington Streets, facing south. The road goes through downtown to the crest of the hill at Sixth Street. (Courtesy of Jim Miller.)

John Jacob Lutz immigrated to America in December 1860 and immediately enlisted in the Missouri Infantry. The Act of July 17, 1862, allowed him citizenship without a previous declaration of intention. J.J. Lutz Sr. came to Papillion in 1885 and quickly became an industrious and important citizen. He served on the town board and was a charter member of the Dahlgren Grand Army of the Republic (GAR), which met in Papillion monthly. His son J.J. Lutz Jr. followed quickly in his father's footsteps in terms of character and married Sussie Thompson in 1899 (they are pictured below), from which two children were born. After Sussie's death in 1909, J.J. Jr. married Anna Dennison, and they had three children. J.J. Sr. died in 1934 as the last Civil War soldier in Papillion. (Both, courtesy of SCHS.)

Fred Wittmuss is another example of German immigration to the Midwest. He was born in Rappine on the island of Rugen, Germany, in 1854 and worked his first job at age 10 after his father died. He moved to Nebraska when he was 27 and became a member of the United Methodist Church, which held services in German. (Courtesy of Deloris Wittmuss.)

In 1885, Fred Wittmuss married Anna Fricke in her parents' home, and they began a family on a farm near Portal where they lived for 21 years. They had five sons—pictured from left to right with their parents—Frances, Harry, Walter, Albert, and Arthur, all of whom were given 160-acre farms by their father. (Courtesy of Deloris Wittmuss.)

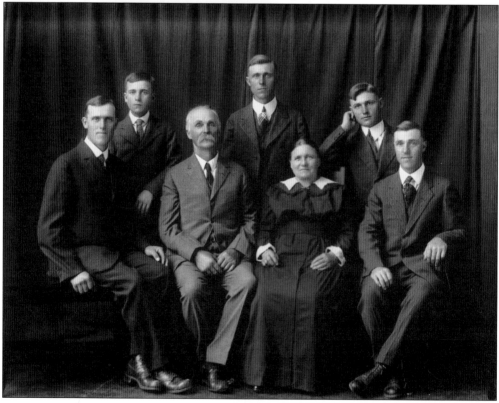

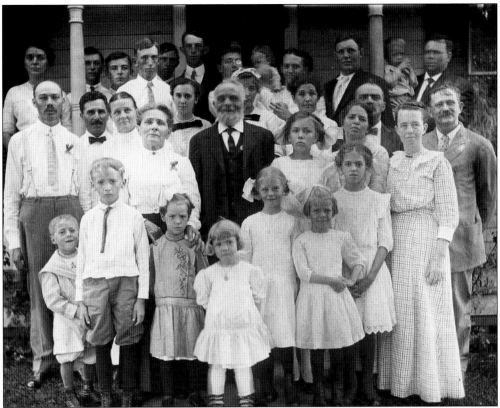

German-born Andrew Fase came to America and married Sophia Timme before migrating to Nebraska from Ohio in 1864. They lived with the Fred Fricke family for the first year and then bought a farm near Portal. They suffered many hardships and nearly lost everything when a prairie fire destroyed all but their home. For more than a century, Papillion has been home to descendants of Andrew and Sophia. (Courtesy of Brad Stephens.)

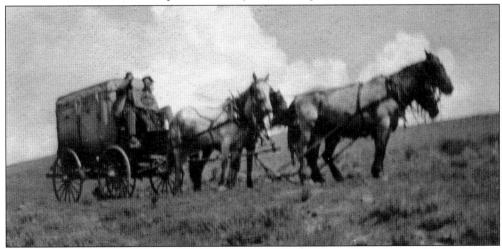

Catching sight of a stagecoach was not unusual around Papillion up until to World War I. This photograph was found in the collection of Fred Ray Lamb and was entitled "Papillion Stagecoach." The Lamb family came to Papillion in the early 1900s. (Courtesy of PAHS.)

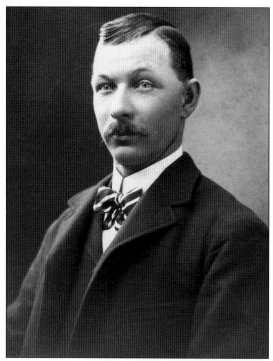

Ernest Weiss Sr. farmed northwest of Papillion with other pioneering families, such as the Uhes, Frickes, and Sautters. They were charter members of the First Lutheran Church and were fundamental to the establishment of the Portal School District in 1870. Ernest served as a director of the school when it was held in the first building near Hell's Creek. (Courtesy of Butch Weiss.)

The Sautters and Weisses were close friends. According to Butch Weiss, his grandfather and John Sautter both attended the First Lutheran Church and would find each other on Sunday mornings and sit together. Sautter donated land to the church to start a cemetery, which is now known as the Papillion Cemetery, located at Eighty-fourth Street and Giles Road. From left to right in the image are John and Mary Sautter and Marian and Ernest Weiss. (Courtesy of PAHS.)

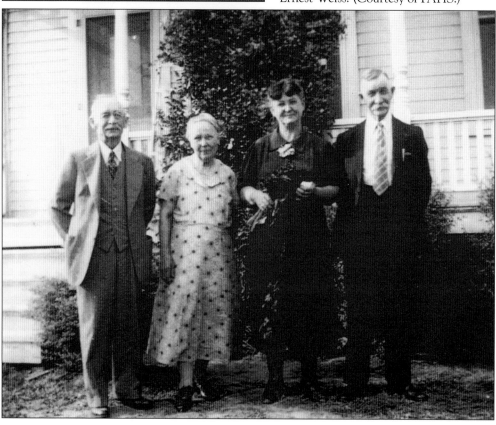

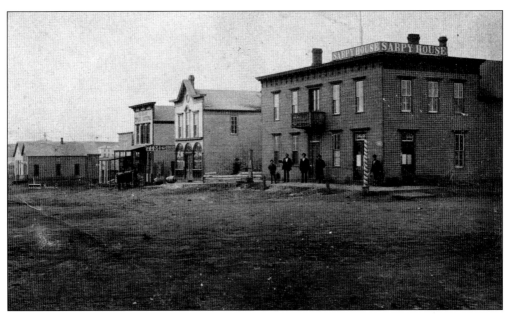

The Sarpy House Hotel was built in 1870 by John Eisele. It boasted of clean rooms, a restaurant, barbershop, and a barn, which housed the horses that guests rode into town on. William Jennings Bryan was a frequent visitor and good friend of Edgar Howard. Howard became Bryan's secretary when he was elected to Congress. (Courtesy of Jim Miller.)

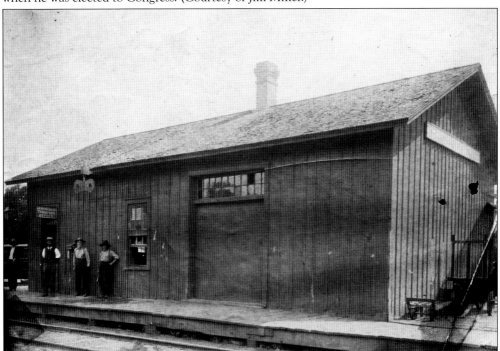

The Papillion Depot brought a population boom of its own. By the census of 1910, several area residents opened their homes as boardinghouses to railroad workers. In the town of Portal, the railroad erected a section house, which the *Papillion Times* reported as "full with a gang of men" in the early 1900s. (Courtesy of Lee Brown.)

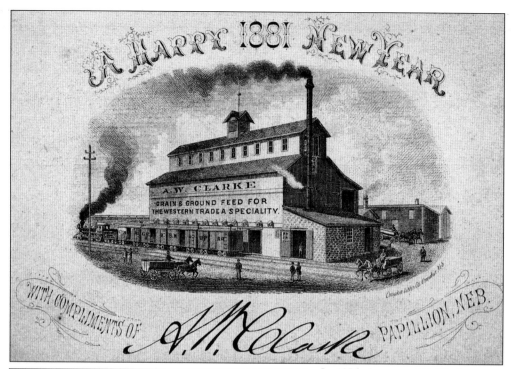

A HAPPY 1881 NEW YEAR

A.W. CLARKE
GRAIN & GROUND FEED FOR
THE WESTERN TRADE A SPECIALITY.

Omaha Litho. Co. Omaha, Neb.

WITH COMPLIMENTS OF A.W. Clarke PAPILLION, NEB.

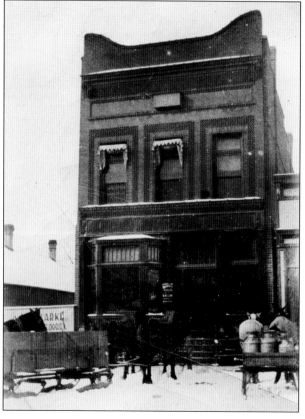

In 1875, Augustus W. Clarke came to Papillion and conveniently built a general merchandise store and grain elevator alongside the railroad tracks. Here, he bought grain and sold merchandise to farmers who often left their money with Clarke until they needed merchandise at the store. By 1880, Clarke had been entrusted with $50,000 of his customers' money. He realized he would become a banker when he began paying funds to third parties upon request. In 1880, he partitioned a space with chicken wire and posted the sign, "A.W. Clarke, Banker." Two years later, he moved the banking side of his business to a building near First and Washington Streets. Clarke's bank building is now the home of Your Country Connection, owned by Vickie Petz, who has restored and preserved much of its original charm. (Above, courtesy of SCHS; left, courtesy of Brad Stephens.)

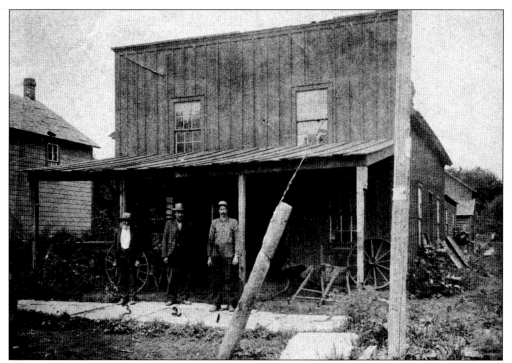

Absolom W. Critchfield came to Papillion from Florence, Nebraska, in 1875. He began a blacksmith shop and carriage-making business just north of the Papio Creek, where Papillion's Flower Patch is today. He returned to Florence in 1878 and married Isabel Reeves and came back to Papillion, which is where they made their home. He sold the business in 1910 to Otto Meyer. (Courtesy of SCHS.)

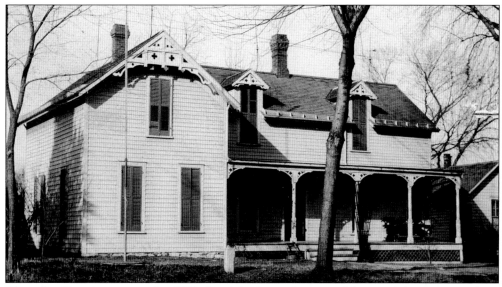

When Papillion incorporated in 1883, Critchfield served as one of the town's first trustees, along with A.W. Clarke, William Sander, and J.E. Campbell. William Robinson became the first mayor. The Critchfield home, which was located on First Street and in the vicinity of the Belvedere, was a reflection of his status. (Courtesy of SCHS.)

The social esteem for Isabel Critchfield can be seen in her collection of invitations to society events at the Sarpy County Historical Society. This invitation to the Ladies Society Club's dance was accompanied by those to high teas, dinners, graduations, weddings, and card games. One invitation is trimmed in black, indicating that the sender was in mourning. The Ladies Society Club was a temperance association affiliated with the Presbyterian Church. Dr. Mary Hoagland Upjohn, who served on the reception committee of this event, was an 1877 University of Michigan graduate who signed the county doctors' registry as a practicing physician in Papillion in 1881. She and her husband, Dr. William C. Upjohn, stayed in Papillion until 1901, when they moved to Omaha. William was a first cousin to Dr. W.E. Upjohn, founder of the Upjohn Pharmaceutical Company. (Both, courtesy of SCHS.)

The presence of yourself and your gentlemen friends is requested at a Leap Year dancing party, to be given by the Ladies' Society Club, at the Papillion Opera House, on Thursday evening, February 11, 1892.

INVITATION COMMITTEE:

MRS. M. P. BROWN,         MRS. J. E. CURTI,         MISS MATTIE SPEARMAN,
             MISS JESSIE IRELAND.

FLOOR MANAGERS:

MRS. J. E. CAMPBELL,      MRS. I. D. CLARKE,        MISS AGNES HARTMAN,

RECEPTION COMMITTEE:

MRS. JAMES HASSETT,       MISS IRELAND,        DR. MRS. UPJOHN,
      MISS MABEL KNAPP,    MRS. EDGAR HOWARD.

William Robinson came to Papillion in 1877 from Bellevue and was appointed the first mayor of Papillion in 1883. He was astute in business and had many friends. Robinson built a home at 244 East Third Street, which was passed down to his granddaughter Nellie Tower, who lived to be over 100 years old. (Courtesy of SCHS.)

Widow Christina Elsass Beerline travelled to Papillion by covered wagon with her six children and a few belongings. She settled south of Papillion and built a farm with her sons, growing a select strain of barley that was malted and sold to Omaha brewing companies. Those pictured are, from left to right, (first row) Mike, Christina, Kate (Eaton), and Henry; (second row) George, Bill, and John. (Courtesy of Bill Beerline.)

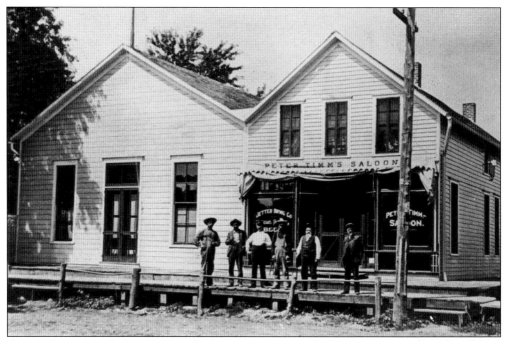

As was the custom, breweries owned or were part-owners of saloons to ensure the sales of their products. Jetter Brewing Company's main brewery was in South Omaha, and the firm owned several saloons across the area, including that of Peter Timm. The German Home Society, which exceeded 500 members prior to World War I, was located in the building on the left. Note the boardwalk in Papillion in this turn-of-the-century photograph. (Courtesy of Jim Miller.)

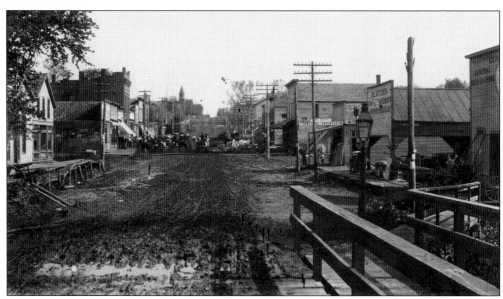

Floodwater from the Papio Creek was an unwelcome manifestation in homes and businesses. This photograph shows the town in recovery after a flood wrecked the streets and boardwalk in front of Peter Timm's Saloon (left). In the middle of the street, men pile debris and pump water from the basements of the businesses on the main street of town. (Courtesy of SCHS.)

In 1903, this Restaurant and Meat Market occupied the property where Brownie's Watering Hole is today, just east of Second and Washington Streets. Men in front of the building are, from left to right, James Galewood, Frank Kowski, unidentified, Conrad Doengis, unidentified, and Jesse Wright, whose little dog proudly poses in several downtown photographs in 1903. (Courtesy of SCHS)

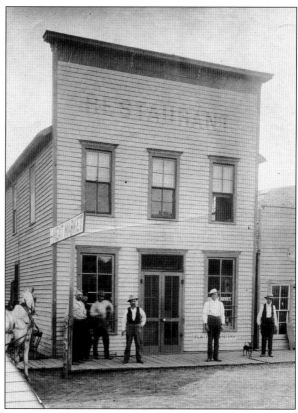

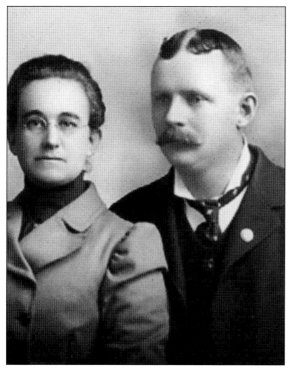

In 1906, Storz Brewery razed the restaurant and erected a new building, which opened as the Storz Saloon, owned and operated by Henry Niemann (pictured with his wife Tillie [Ruff] Niemann). Niemann was a charter member of the Papillion Commercial Club and owned several businesses throughout the years. The Storz Building frequently changed hands over time. Frank Deerson, Hugo Cordes, Mike Gold, and Charlie "the 'rassling sheriff" Peters are a few of the men who owned the structure now known as Brownies Watering Hole. (Courtesy of Rodney Ruff.)

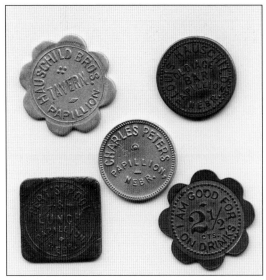

In the early 1900s, saloon and pool hall owners in Papillion had brass or tin coins made with the name of the business on one side and a denomination on the other. These coins were used as promotions and round markers. Lee Brown of Brownie's Watering Hole observes the custom with a wooden chip. (Left, courtesy of Brad Stephen; below, courtesy of Lee Brown.)

In 1915, the Storz bar was sold to Hoffman and Halliday, who turned it into the Alyce Movie Theater. It ran for several years before it changed hands and became the Central Theater. In 1933, Prohibition was repealed by the passage of the Twenty-first Amendment, and Charlie Peter bought the theater and remodeled it into a pool hall. Peter purchased a bar from the Zeeke Hotel that is now an interesting attraction at Brownie's Watering Hole, which operates out of the building today. (Courtesy of Lee Brown.)

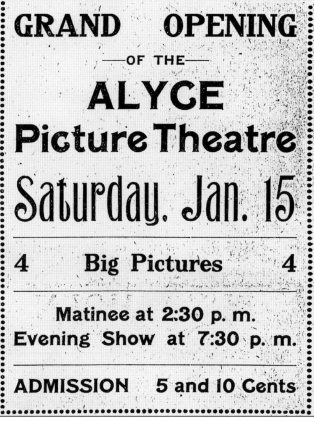

# GRAND OPENING
—OF THE—
## ALYCE Picture Theatre
### Saturday, Jan. 15

4     **Big Pictures**     4

Matinee at 2:30 p. m.
Evening Show at 7:30 p. m.

ADMISSION     5 and 10 Cents

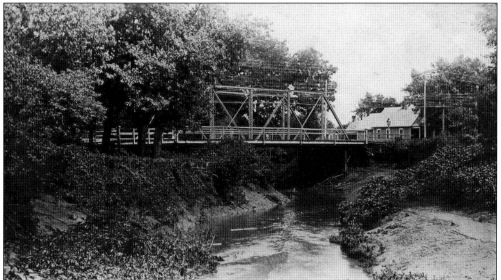

This postcard exhibits the creek's natural beauty in the early 1900s. The downtown boardwalks extended across the wooden bridge with a pedestrian walk, lest anyone be run over by a horse and buggy. The gas streetlights were in place until 1910, when electricity was turned on. (Courtesy of PAHS.)

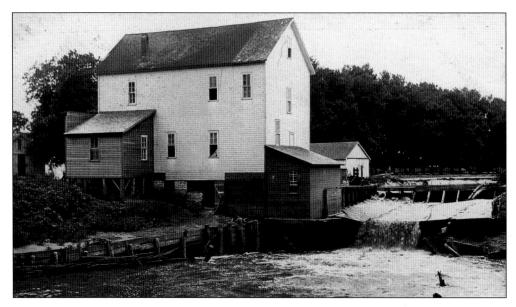

Far from the present is the sound of water flowing around the mill, which sat near the bend of the Papio Creek, just west of the Washington Street Bridge. In 1890, Charles Hagadorn opened for business in the U.P. Mills under a new name, Papillion Roller Mills. The news of his ownership was second to the buzz created in the *Papillion Times* that boasted of the improvements to the mill, which included a gasoline-powered engine in 1898. The mill produced up to 75 barrels of flour per day, under the Papillion Star label. (Above, courtesy of PAHS; below, courtesy of SCHS.)

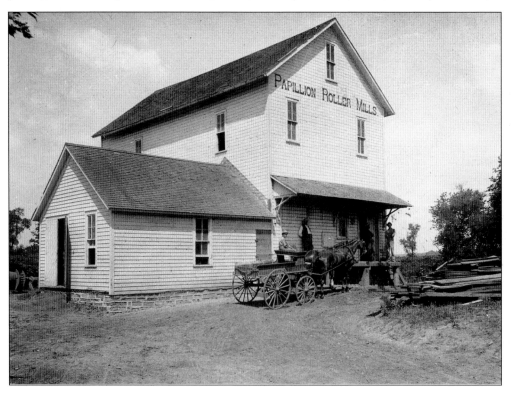

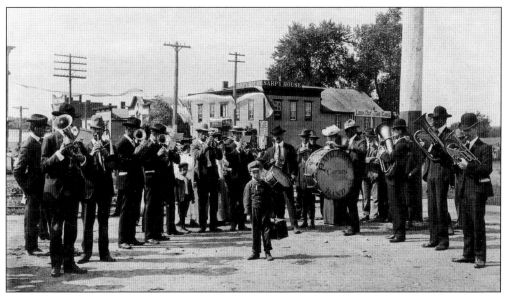

The people of Papillion are historically creative in areas of the arts, literature, and music. In the early days, Fourth of July parades were an important community celebration. Men would bring their farm implements, fancy buggies, and prized pigs to march the main street to the music of the Papillion Cornet Band. The drum from this band is on display at the Sarpy County Historical Society. (Courtesy of SCHS.)

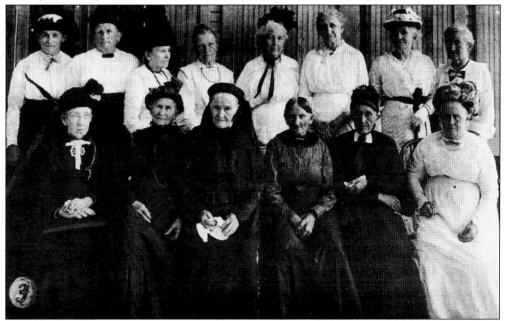

The women of the Old Settlers' Association in Papillion pose following a picnic in 1914. Many women of the day gave the names of their husbands when asked to identify themselves. That custom is reflected in identifying those pictured. They are, from left to right, (first row) Marion Fish, Amos Gates, Mary Dunn, Fred Fricke, Parmelie Holman, and S.M. Pike; (second row) W.J. Armstrong, Jacob Pflug, Robert Laing, Catherine Jewett, A.W. Trumble, Mary Chase, Anna Miller, and Eliza Sprague. (Courtesy of PAHS.)

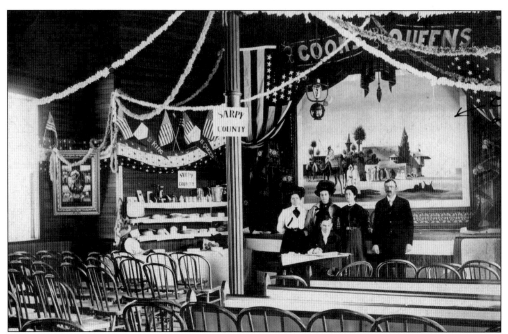

The opera house was a treasure in its day. Locals presented literary, dramatic, and musical shows between scheduled performances by traveling acting troupes and medicine shows. On this occasion, it was used as an exhibit hall for the Sarpy County Fair, where "Corn is King" and "Alfalfa is Queen." Those standing in the photograph above are, from left to right, Anna Fase, Mrs. Adam Gramlich, Mrs. Truman Sabine, and Edward G. Fase. The gentleman seated is John Grinnell. Below, the woman sitting is Mrs. Truman Sabine, with Mrs. Adam Gramlich behind her. Seated on the right is John Grinnell, with Edward G. Fase and M.P. Brown to the right and left of him. A photograph of the outside of the opera may no longer exist. (Both, courtesy of SCHS.)

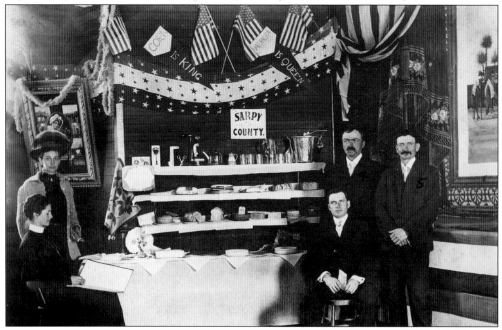

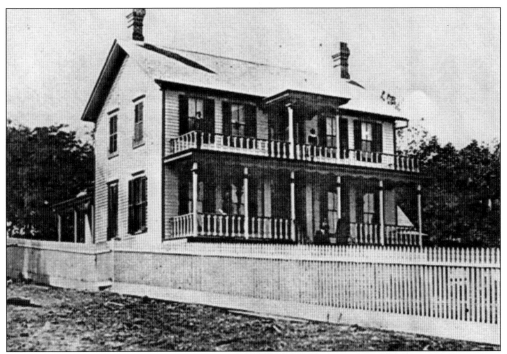

Another Papillion treasure is that of the Fricke family, whose ancestors rank among the first to homestead in Sarpy County. In 1858, Julius Fricke settled northeast of Papillion in a sod house. The family continued to grow. In 1890, Frederick Fricke and his wife, Elizabeth, built a beautiful house on their homestead, which was located where the Eagle Hills Golf Course is today. (Courtesy of Midlands Community Foundation [MCF].)

Frederick's son Milton was born in 1909 and is an icon of Papillion church and community pride. He graduated as valedictorian from Papillion High School and went on to attend classes at the University of Nebraska. When his father suddenly died, he returned to the farm in 1930. He met Verna Butterworth, an Omaha "city girl," and married her in 1934. (Courtesy of MCF.)

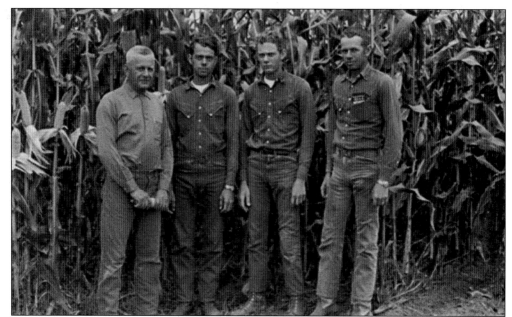

The Frickes were kind to the land. The fact that the land provided them with the means to live was secondary to their commitment to keep a certain section of virgin lowland prairie natural and sacred. The protected land is a precious gift to prairie enthusiasts. Milton shared his ancestors' farming traditions with his sons, who assisted in the farm's operation until the area was commercially developed as Settler's Creek. Those pictured are, from left to right, Milton Sr. and sons Charles, Leon, and Milton Jr. (Courtesy of the MCF.)

Milton Fricke Sr. led by example in soil and water conservation by honoring conservation farming methods, such as terracing, contour farming, and the creation of drainage ditches. In 1945, Milton helped organize the Sarpy County Soil Conservancy District and, in 1958, wrote the Nebraska Watershed Conservancy Law, which passed the unicameral legislature. In 1985, he was awarded the National Endowment for Soil and Water Conservation Award for the State of Nebraska. (Courtesy of the MCF.)

# *Two*

# THE ART OF BUSINESS,
# THE MATTER OF FAMILY
## A COMMUNITY GROWS

In 1870, several business-minded citizens recognized the advantage of Papillion's central location and embarked on a quest to further ensure their stability and growth by organizing the Papillion Town Company, which raised funds to build a courthouse and replace Bellevue as the county seat. Capt. J.D. Spearman, an organizer of the village of Sarpy Center and fierce competitor for the county seat, joined the impassioned race of tenacity and wit.

An agreement was struck wherein the two communities with the most votes in a preliminary election would face off in a final battle at the polls. Sarpy Center took the lead, with Papillion coming in second, at which time brothers Herman and Albert Sander of Papillion stepped into the fight. The Papillion Town Company had not raised the full amount needed to build the courthouse structure, so the Sander brothers sweetened the pot by donating the site for the courthouse as well as two other lots, which were sold for profit. The location of Papillion was now the most logical choice, which inspired Captain Spearman to use his political powers.

As a county delegate to the legislature, Spearman introduced a tough bill that appointed Sarpy Center as county seat without the necessity of further elections. County commissioner Alois Gramlich spoke loudly against the measure and, with great difficulty, won the favor of other elected officials to keep the issue in the hands of the voters. The bill failed.

On April 6,1875, an election was held, and citizens from around the county came to Bellevue to cast their votes. Papillion was favorably chosen and immediately began to flourish from the prestige and profit of being the county seat.

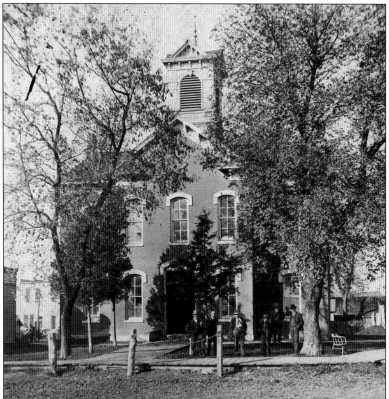

Papillion became the county seat by popular vote, and its first courthouse was built in 1875. It was located between First and Second Streets and Jefferson Street. In 1923, a new courthouse was constructed, and the original one was bought by Hugo Cordes, who tore down the top floor and reused the bricks to add onto the back of the building, which is now Ron's Automotive. (Courtesy of Brad Stephens.)

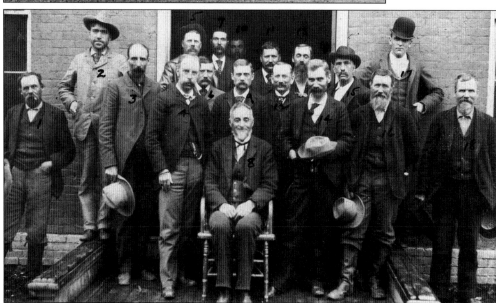

Here are Sarpy County officials around 1890. Those pictured are 1. Calvin Jewett, 2. Edgar Howard, 3. Howard Whitney, 4. S.O. Salisbury, 5. Frank Ryling, 6. Claus Grell, 7. unidentified, 8. Judge Hoyt, 9. M.E. Stormer, 10. unidentified, 11. Don Mariman, 12. Tom Coleman, 13. William F. Martin, 14. George Hemstead, 15. Jim Groves, 16. J.D. Patterson, 17. Archie Knapp, and 18. Ben Holman. (Courtesy of PAHS.)

Do not be fooled by the calm expression of Papillion's skylarking icon, Ernest "Blondy" Ruff. The University of Nebraska graduate was one of the youngest elected county officials and a prankster extraordinaire. As part of his courthouse "duties," he accepted a "bloodthirsty challenge" to a baseball game against the Douglas County Gang. As a competitive athlete and even more competent wise guy, he ran his response on the front page of the *Times*, declaring the boys from Douglas are considered residents when they cross the line and that their estates would be in probate here upon their expiration on the field. They were thus advised to "bring as many millionaires as possible." Those pictured, from left to right, are (first row) Blondy Ruff, H.A. Collins, and two unidentified men; (second row) Emil Grothe, Deputy Hamilton, Sheriff Startzer, Judge Begley, and George Ireland. (Right, courtesy of Rodney Ruff; below, courtesy of PAHS.)

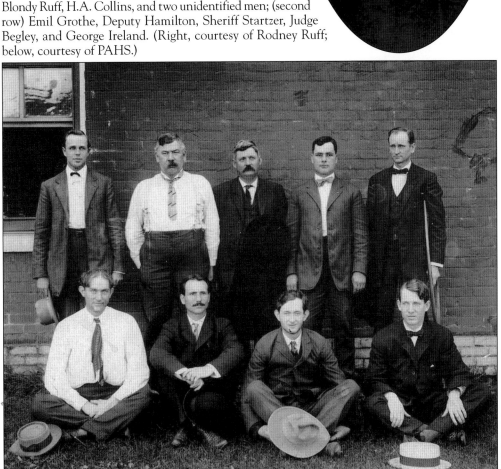

31

The first floor of the courthouse had courtrooms and offices for the county clerk and treasurer. Those pictured below are, from left to right, Blondy Ruff, county clerk; James Begley, district court judge; and Grant Chase, sheriff. In 1912, Chase helped to assemble a posse of over 150 men after three escaped convicts from the state penitentiary were en route to South Omaha. Charles Taylor, John Dowd, and Charles Morley killed two wardens, stole a wagon, later dubbed "Ol' Hickory," and kidnapped Roy Blunt, a newly wed Springfield farmer. The convicts made Blunt drive the getaway wagon while running away from the posse; Blunt was accidently killed in the pursuit. One convict was killed, one captured, and the other committed suicide. After the inquest, Chase resigned as sheriff. The second floor of the courthouse had an office for the superintendent of county schools and a large auditorium. (Above, courtesy of PAHS; below, courtesy of SCHS.)

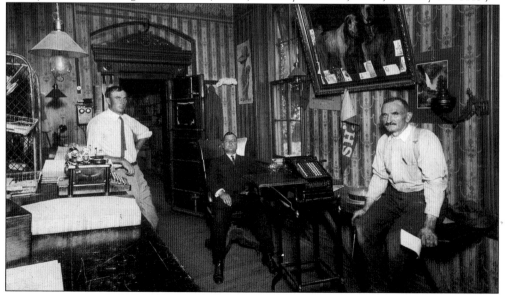

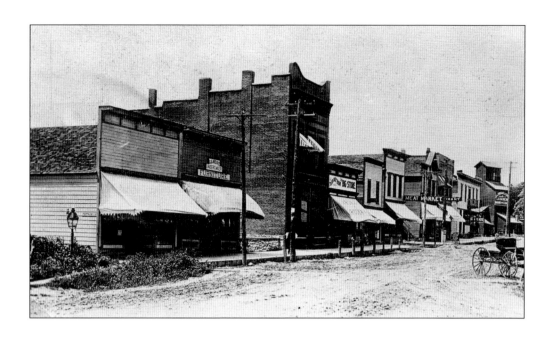

These 1912 postcards of the east and west sides of Washington Street reflect the community's business growth. On the west side (above), C.S. West Undertaker and Furniture shop, A.W. Clarke Banking House, the Hayhow Big Store, the Sarpy House Hotel, and J.C. Wright and Sons were healthy business operations, with some having opened as early as 1869. On the east side (below), D.D. Pacey set up a tinning shop, and the Curti Drugstore was a convenient stop for patients of Dr. Magaret, who had an office above what is now Tom's Papillion Shoe Repair and Savannah's. The presence of fire hydrants and utility poles were modern features, although the streets remained unpaved until 1918. (Above, courtesy of Brad Stephens; below, courtesy of PAHS.)

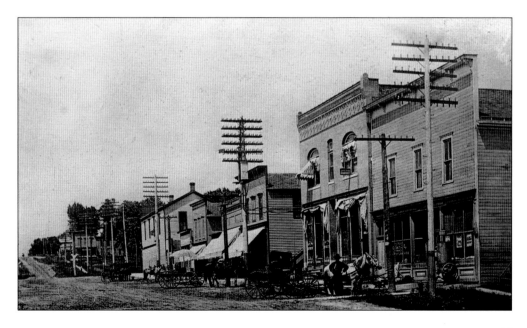

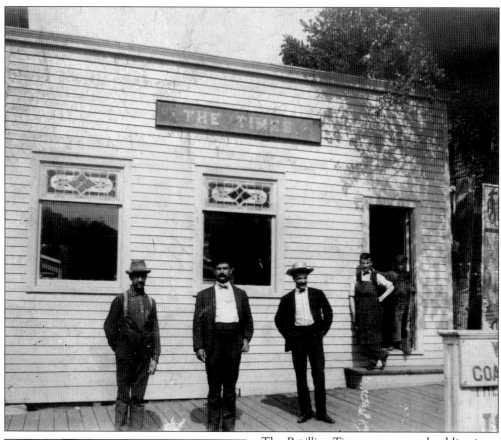

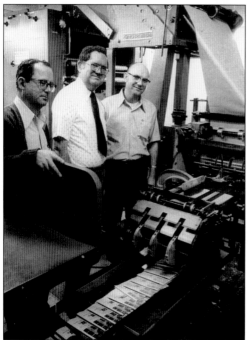

The *Papillion Times* commenced publication in 1874 under J. Frank Wharton, who sold it to A.R. Kennedy in 1875. It changed hands several times to include editor Edgar Howard, who became a state legislator and a member of Congress. In 1903, a joint partnership between George P. Miller Sr. (second from the left) and Dale McClaskey (third from the left) ran the paper until Miller's death in 1949. The other men pictured are unidentified. (Courtesy of SCHS.)

Upon his father's death, George Miller Jr., a graduate of the University of Nebraska, began operating the paper. In time, his brother Jim, also a University of Nebraska graduate, joined the operation. The enterprise was complete when Jack joined the fray, and the paper remained in Miller control until the 1980s, when Suburban Newspapers Inc. purchased it. Pictured are Jim (left), George (center), and Jack Miller. (Courtesy of the Miller brothers.)

Seely B. Knapp was one of the first station agents in the depots at Papillion and Gilmore and a member of the 1875 Papillion Town Company. The duties of a stationmaster included keeping the books and being responsible for the operation of signals, points, and other electrical communication instruments. (Courtesy of SCHS.)

In 1869, the Union Pacific Railroad agreed to put down a sidetrack through Papillion and to build a suitable depot. In 1882, the Missouri Pacific Railroad Company extended its line from the southern boundary of the state to Papillion, and its tracks stretched to the Sarpy County line by 1886. The railroad played a major role in Papillion's early growth and stability. (Courtesy of SCHS.)

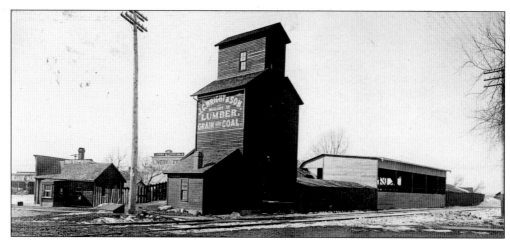

Jesse C. Wright originally settled in Bellevue as a pioneer in 1858. He moved to Papillion in 1869 and opened the J.C. Wright Coal and Grain Company, which also dealt in lumber. In 1896, his son Edward joined the operation as a junior partner, and J.C. Wright and Son became the official name of the business. Edward was educated in the Papillion schools and was considered a young man with remarkable abilities in the area of business. For many years, they were the only dealers in lumber and coal in the village. There are many receipts for coal purchases, written by Jesse and Edward, in the records of the Portal School District. Jesse's small dog appears in a number of Papillion photographs at the turn of the century. (Both, courtesy of Brad Stephens.)

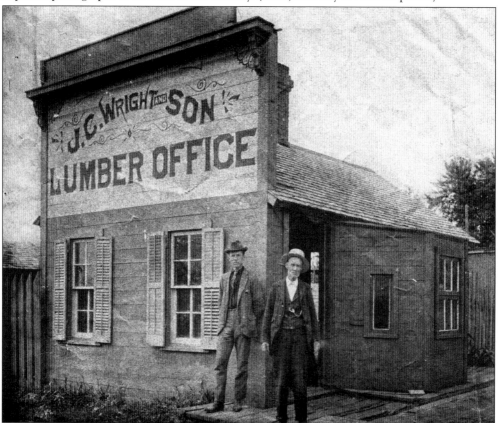

The number of people coming into Papillion via the railroad to go to the courthouse or do other business quickly grew. This drugstore is present in the earliest photographs of Papillion and is believed to have been owned by a Cordes. The building was still standing in 1903 but became the site of Bell's Hall in the years to come. (Courtesy of SCHS.)

Fred Hayhow sold general hardware and merchandise and changed the name to Hayhow's Big Store in the 1920s. The F.P. Kirkendall and Company advertisement for shoes, located in the window, referred to the Kirkendall Boot Factory, which was established in the Millard Block of the Old Market in Omaha. At the time, the factory was the world's largest producer of riding boots. (Courtesy of Jim Miller.)

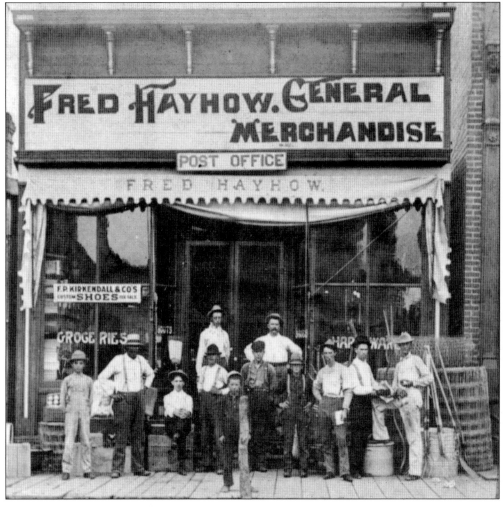

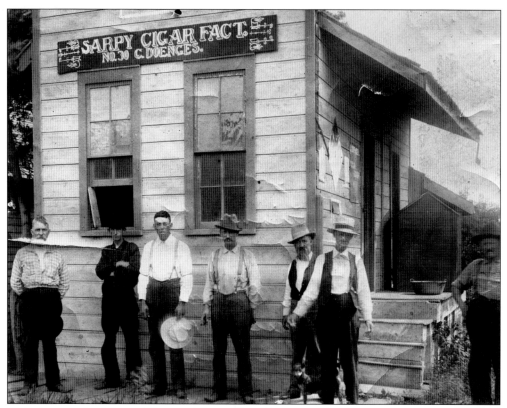

This photograph of Conrad Doenges's Sarpy Cigar Factory produces an interesting question: does the sign, which indicates it is factory No. 30, imply that it may have been a type of franchise? Those pictured are, from left to right, James Galewood, Frank Kowskie, next two unidentified, owner Conrad Doenges, the most-photographed dog in Papillion and owner Jesse Wright, and Chris Saalfield. (Courtesy of SCHS.)

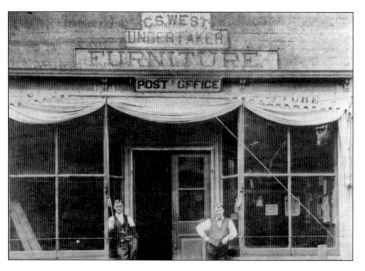

Every town needs an undertaker, and Papillion had two almost directly across the street from one another. At that time in history, a furniture maker was a logical choice to build coffins and caskets. C.S. West sold caskets and advertised having a funeral casket, which would have been set up for use in a funeral but not used in the burial. (Courtesy of Jim Miller.)

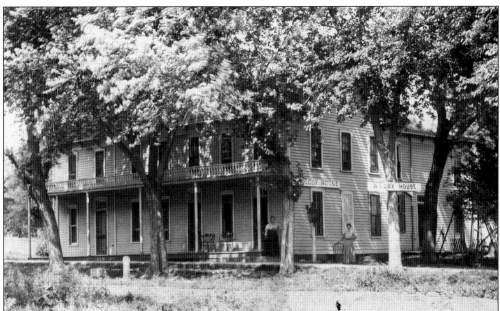

Postcards were an important form of advertising in many small towns. The bustling community of Papillion got mixed reports on the back of several postcards dated from 1909 to 1915. Some thought the town a bore, while others believed it was a quaint place to spend a day shopping with a lunch picnic in park and dinner with friends at Bell's new drugstore. It was common for the interurban trolley line that ran from Omaha to Papillion to hold over if a social event was in full swing. If patrons decided to stay, there were plenty of hotel options. The Sarpy House offered a bounty of amenities, such as a barber, restaurant, bar, and billiard room, as did the Wilcox Hotel, which also ran a bar and restaurant on its premises. (Both, courtesy of Brad Stephens.)

They all take their time in Papillion, Nebraska

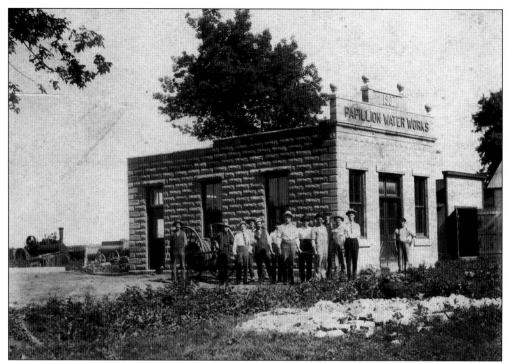

The Papillion Water Works was built in 1907. That year, Henry Niemann and several other businessmen supported the Commercial Club's fireman's sale day to raise funds for firefighting equipment and to build a house to store it in. The Papillion Water Works Building was constructed with city funds, but the hose cart, alongside the building, was one of Papillion's first pieces of firefighting equipment purchased with donations. (Courtesy of SCHS.)

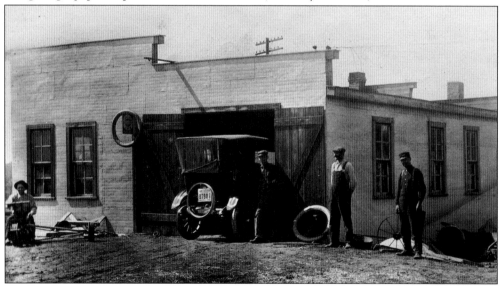

The Lundgren brothers opened a mechanic shop after 1920, and it was located not far from the Elkhorn Condensing Plant. The popularity and affordability of the new Ford Model T kept the young mechanics busy. The days of the blacksmith were coming to a close in favor of businesses that repaired engines instead of horseshoes and carriages. (Courtesy of SCHS.)

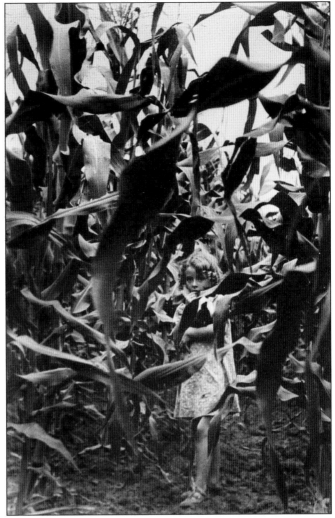

These photographs, found in a collection donated to the Papillion Area Historical Society by Fred Ray Lamb, tell an important story of Papillion's harvest in the early 1900s. The little girl surrounded by cornstalks creates more than a pleasing image; she is witness to the size of the stalks. The height of an average six-year-old girl is about three feet and six inches, and the height of the corn that year looks to be about seven feet and six inches tall. "Papillion boys harvesting corn" is penned on the back of the photograph below. They still used horse-drawn wagons to carry the corn to storage. Corn sold for about 0.42¢ a bushel in 1915. (Both, courtesy of PAHS.)

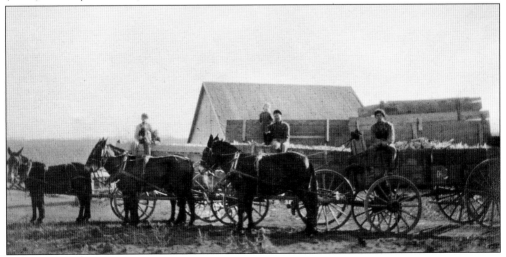

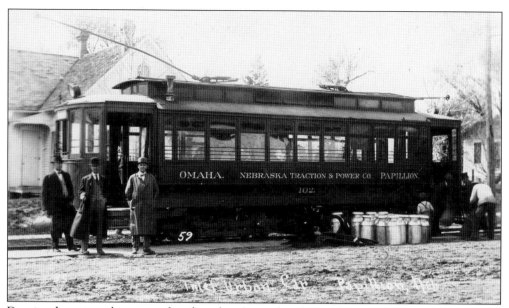

Despite the rain, a large crowd gathered at Second and Washington Streets at 5:50 p.m. on October 1, 1911, to meet the first interurban car from Omaha. The first to buy a ticket was I.D. Clarke, with G.P. Miller next in line. The line ran north into Omaha, and it cost 5¢ to ride to the county line, 10¢ to Ralson, 15¢ to Homestead, 20¢ to South Omaha, and 25¢ to Omaha. Farmers, such as John Sautter, used the interurban to ship fresh milk to South Omaha. The line was expected to be extended into Richfield, but an advance in transportation introduced buses, which were more comfortable, and by 1926, the tracks were removed. (Above, courtesy of PAHS; below, courtesy of SCHS.)

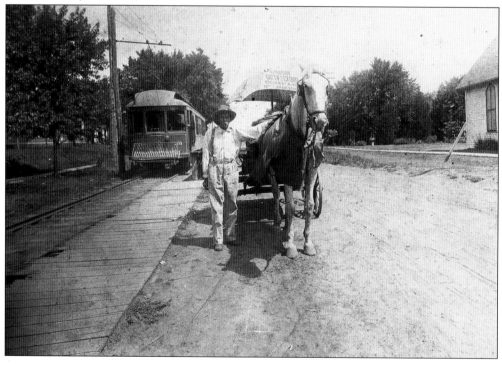

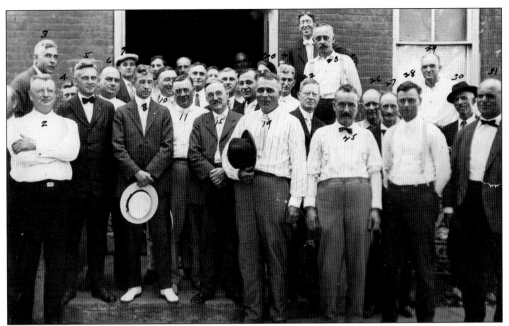

There is some debate about the nature of the gathering depicted in the photograph. One theory is that a group of driving enthusiasts gathered in front of the courthouse to protest the hiring of a speed cop in town. The second suggests they are a committee to improve road conditions in the county. Regardless of the reason, Papillion was a "hot" community during the 1920s. In these times, Judge James Begley tried to convince the town council to outlaw dances such as the Turkey Trot and the Hoo Chee Coo Chee, and Sheriff Olderog was a regular feature in the *Times* as he raided bootleg operations. Papillion hired a speed cop, Mike Zwieble, because "high speed trains going in one direction did not mix with high speed cars going in the other." (Above, courtesy of SCHS; below, courtesy of Brad Stephens.)

Had a hot time in

Papillion

hugged the stove

COP. S. A. S., 1912

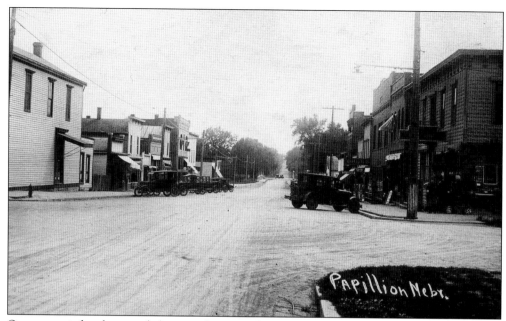

One way to judge the period photographs were taken in Papillion's downtown is by the condition of the street. Papillion looked ahead in many ways but lagged behind in the paving of its main street, which was not completed until sometime in 1921. The *Times* reported brick was laid over concrete and covered with asphalt to the tune of $400 a yard. When the project was complete, the community celebrated with a dance. (Courtesy of Brad Stephens.)

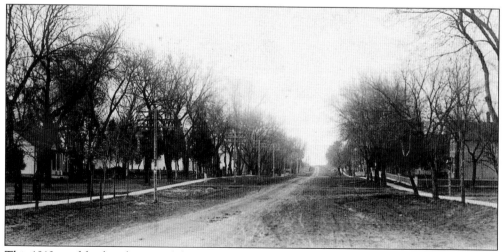

This 1912 neighborhood postcard shows an example of the general tranquility of the town. Many of the early homes have survived but are not of the large Victorian variety. Behind city hall are two homes built in the 1910s that were bought as kit homes, which ranged in price from $500 to $5,000. (Courtesy of Brad Stephens.)

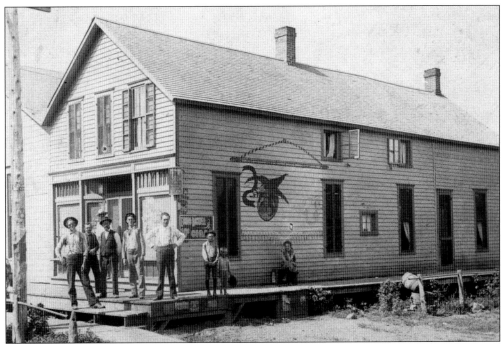

This turn-of-the-century photograph is of the German Home Society and Peter Timm's Saloon. In the early 1900s, it was purchased by Louis Hauschild Sr. and became the Parkside Bar, which was condemned in the 1980s after it sustained considerable damage from a fire. The building, then owned by Louis Hauschild Jr., was never repaired, and after a court order, the city had it razed. (Courtesy of SCHS.)

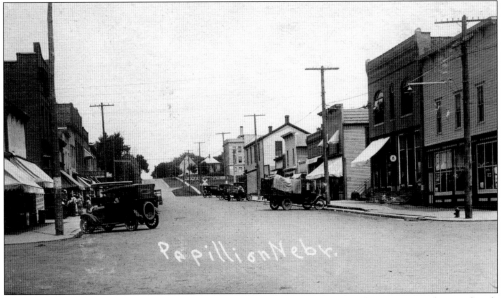

This photograph of downtown shows the progress of Papillion with the new courthouse, hard-surface streets, and the many automobiles that replaced horses and buggies. Although progress was sure, many businesses were still operated by Papillion pioneers, such as H.A. Sanders and A.W. Clarke. (Courtesy of SCHS.)

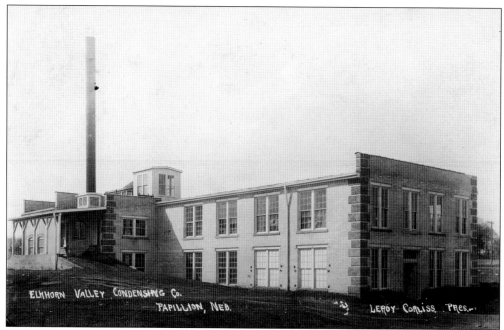

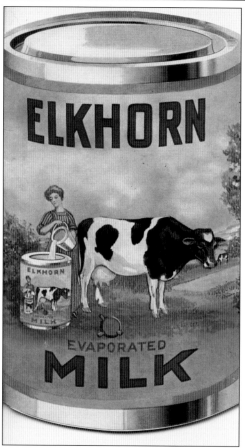

The community had high hopes for the success of the Elkhorn Condensing Plant, which was located where Apple Tree Orchard Daycare sits today. The plant ran for several years when the founder, Louis Corliss, ran into financial difficulties, forcing its closure. A can of Elkhorn Condensed Milk, which is a fine example of the canning process of the day, was found in the home of Esther Wittmuss Lichty at her passing in 2002. The milk was put into the can through a small hole at its base and was then plugged with a small piece of soldered metal; the consumer removed the can's contents by slicing an $X$ on the top of the can with a knife. (Above, courtesy of Jim Miller; left, courtesy of Brad Stephens.)

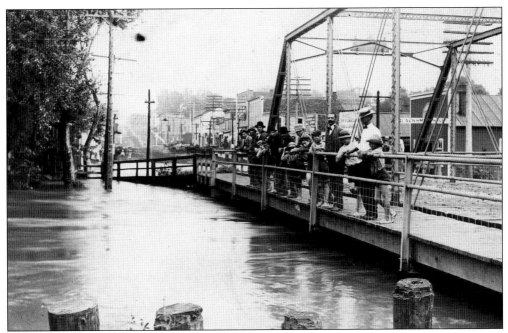

Seen here is a group of citizens watching the water rise on Papio Creek. In the background, the streets of Papillion are still unpaved and destined to become a muddy swamp. Behind the bridge is Fred Ross's blacksmith shop, which will soon be underwater. The bridge will be swept downstream. (Courtesy of Brad Stephens.)

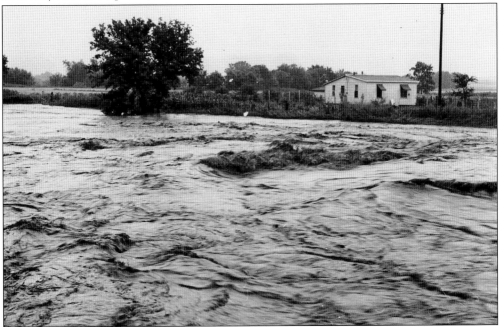

The angry waters of Papio Creek sweep eastward in a dangerous deluge. In one such flood, the offices of the *Papillion Times* were in the basement of the A.W. Clarke Building, which was filled to the top with water, destroying the earliest newspaper archives. Now, there is little to be read of Papillion news from 1877 to 1903. (Courtesy of SCHS.)

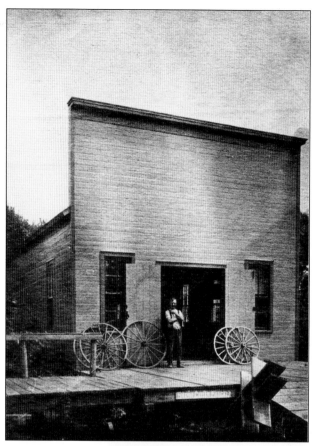

Fred Ross bought Ed Bloedel's Blacksmith Shop sometime around 1903 and carried on the business for many years to come. It was located on the northeast side of Washington Street, which was too close to the frequently flooding Papio Creek. The photograph below may be of the flood of 1917. Ross's neatly painted shop is nearly half full, and wagon wheels and implements suggest it is well before 1959, when a flood took out the concrete bridge. Fred's son Ernest became the more modern version of his father and worked as a mechanic for Kopecky Chevrolet before opening the Ross Motor Company in 1932. (Left, courtesy of SCHS; below, courtesy of Jim Miller.)

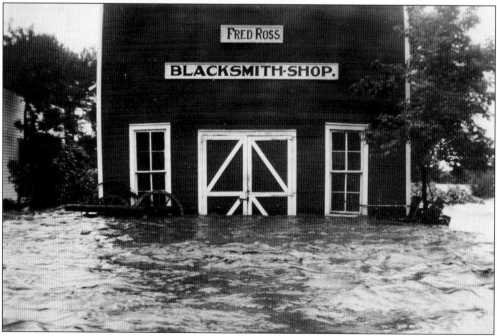

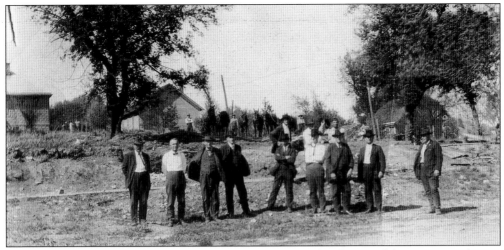

County officials gather at Third and Washington Streets to break ground for a new courthouse. The three-story construction project included a rooftop jail that Sheriff Olderog called "Ole's Rooftop Garden" due to the large number of liquor offenders arrested during Prohibition. On July 4, 1922, the town added the laying of the cornerstone by J.J. Lutz Sr. to its Independence Day celebration. Parades and music filled the streets, and orators, such as Edgar Howard and the Honorable James T. Begley, delivered speeches. The new courthouse cost $150,000 to build and featured a winding staircase and mosaic, tiled floors. Four public and two private bathrooms were installed on the third floor alone, which housed the sheriff's office, an apartment for the jail supervisor, and a district courtroom. (Above, courtesy of PAHS; below, courtesy of SCHS.)

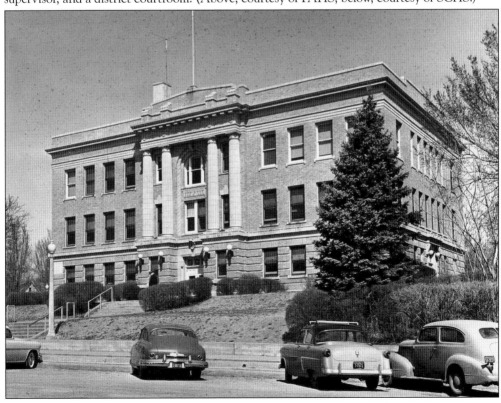

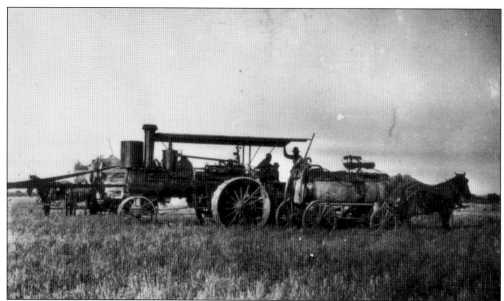

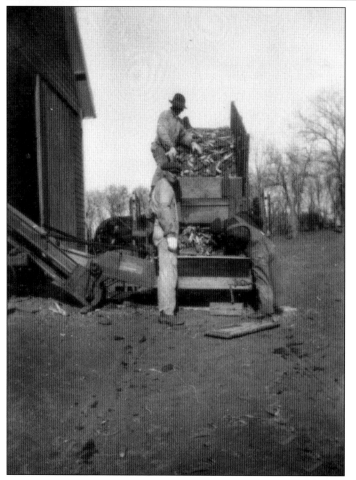

These photographs are prime examples of the type of machinery used to bring in the crops on area farms. These 1932 images are of the Linneman farm, located just south of Papillion. They used a steam engine to separate the wheat from the hay, which is thrown into stacks. The steam engine was strapped to a thresher (not shown) that was pulled across the field. The operation still required the use of horses. By 1938, however, *Papillion Times* editor G.P. Miller had taken a drive to area farms and counted eight tractor rigs in use but not a single horse-drawn outfit. (Both, courtesy of SCHS.)

It is fair to say that one could go around the block to all the former sites of the Papillion Post Office. For many decades, it was located inside one or more businesses along Main Street or in its own building on the same city block—until the early 1960s, when the new facility dedicated to the memory of Pres. John F. Kennedy was built in the area of Eighty-fourth Street and Centennial Road. At right is perhaps the oldest building primarily constructed to handle the local mail. It was on the corner of First and Washington Streets and was moved in the 1950s to Fifth and Monroe Streets, where it stands today, and remodeled into a residence. At that time, the post office was moved into a new structure (below) located around the block, which is now occupied by the Public Works Department and is across the street from the fire department. Over the years, that building also housed a bank and the police department. (Both, courtesy of SCHS.)

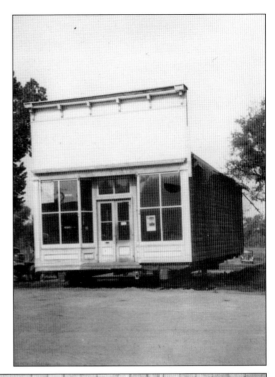

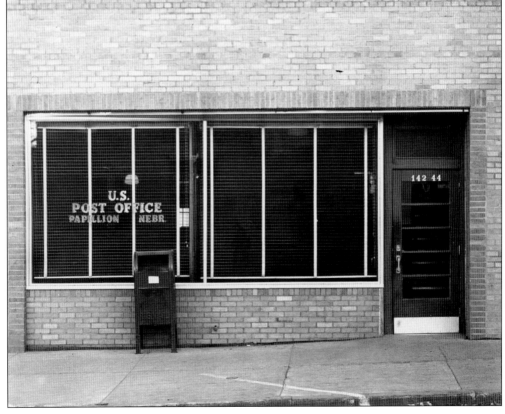

Robin Tower (left), son of Robert and Nellie Tower, was a gifted machine worker. He was also a talented and acclaimed musician who toured the West Coast in 1926 as a musical act working for the Levy Theatrical Company. He played saxophone and clarinet in more than 10 states that year. (Courtesy of SCHS.)

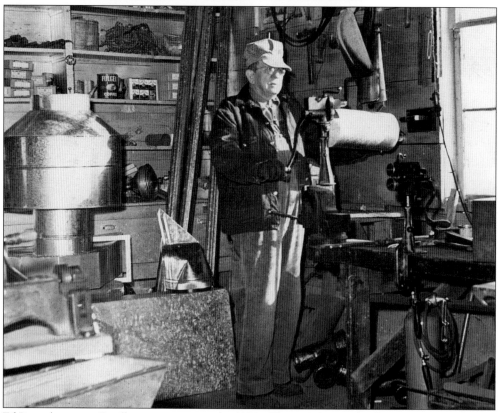

Ed Pacey became a Papillion tin-master in the 1930s. The art of tinwork is lost to mass production. A tin-master made items such as ceiling tiles, buckets, funnels, cookware and even toys. In the early 1900s, Victrola horns were a good example of a tin-master's output. Ed appears to be making ductwork for home or commercial use. (Courtesy of SCHS.)

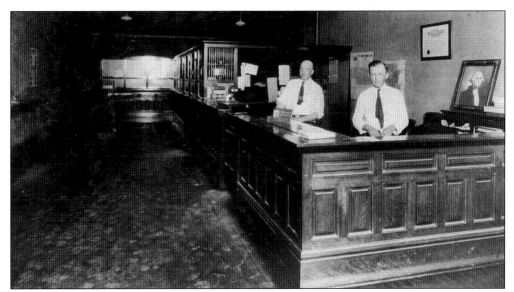

"State Bank Wrecked" was the headline in the *Papillion Times* on July 8, 1926, after bank examiners discovered a shortage of nearly $400,000. President of the bank Edward Goerke (left) and cashier C. Earl Marshall (right) were called to appear before the state banking board, but Goerke never showed. According to the *Times* article, Goerke was presumed to have escaped to Argentina and was never heard from again. C. Earl Marshall was found guilt of forgery and sentenced to the state penitentiary. (Courtesy of the Douglas County Historical Society.)

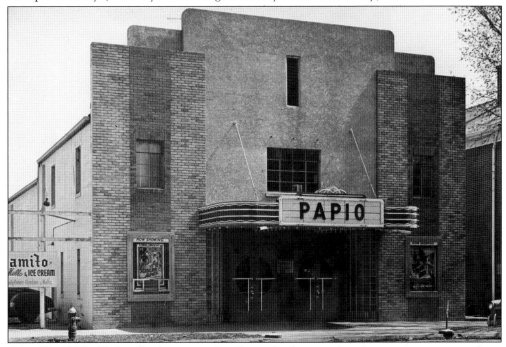

After World War II, Art Sunde came to Papillion after hearing that the county seat was without a motion picture theater. Sunde operated theaters in Elma and Woodward, Iowa. After working out the financial details, he hired Art Stark to build the theater, which is now home to the Papio Creek Baptist Church. (Courtesy of SCHS.)

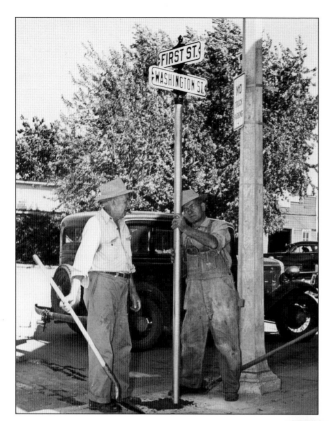

The 1950s brought an improvement to Papillion when the city installed street signs. Holes had to be dug into sidewalk corners and refilled after placing the poles, which citizens reportedly appreciated. (Courtesy of SCHS.)

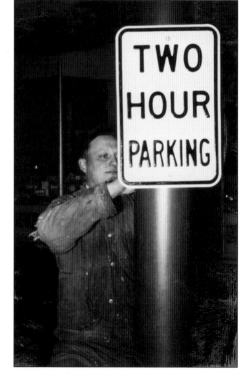

The first parking restriction signs were installed on Washington Street. Downtown Papillion attracted shoppers whose everyday needs were met in the two-block business district. The added traffic of the courthouse made it necessary to limit the amount of time a patron could park along Washington Street. (Courtesy of SCHS.)

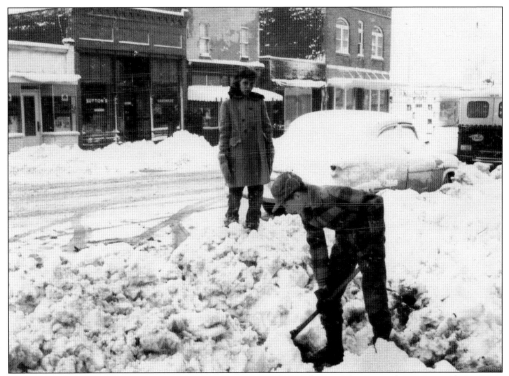

Two Papillion youths clear away the heavy snows that fell in mid-November 1949. That was a year of large crops and heavy snows during the winter months. Out West, farmers and ranchers were caught off guard by the November snowstorm that stopped the railroads and buried cattle standing in the fields. In the East, freezing rain and ice made travel treacherous and brought down electrical lines. Clearing roads was difficult when the drifts reached over the tops of cars. (Both, courtesy of SCHS.)

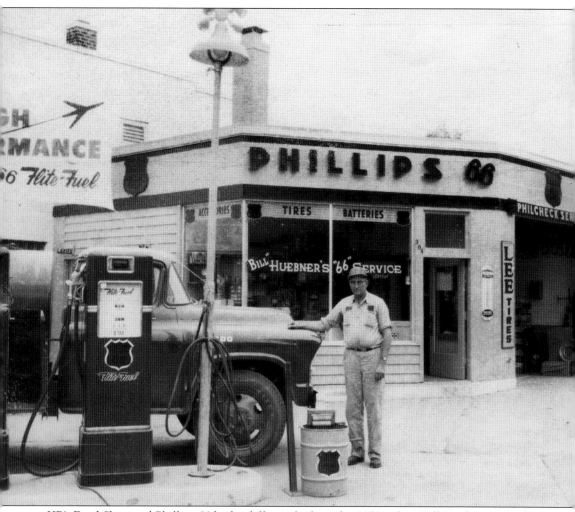

KB's Food Shop and Phillips 66 had a different look in the 1950s when Bill Huebner owned it. Flite Fuel was Phillips 66's premium gasoline. The high-compression engines of the day required fuels that were typically 100-octane, which is about the same as aviation fuel. (Courtesy of Jim Miller.)

# *Three*

# AWAKENING ON THE PRAIRIE
## RELIGION THEN AND NOW

More than a decade before the town of Papillion incorporated, the settlers in the area began to form churches. The earliest congregation is believed to have been Methodist. Members met in dugouts because of a lack of available lumber to build proper homes. In time, the Presbyterians, Lutherans, and Catholics began to meet in various houses or public buildings.

Though the town was small and the settlers were still battling to overcome the harsh Midwest plains, their faith was strong. Through sacrificial giving, they contributed land and monies needed to build churches, three of which have celebrated centennials. Education through Sunday schools contributed as much to a child's learning as the one-room schoolhouses. Papillion is a town filled with people whose faith is as strong as their compassion is deep.

Though St. Paul's Methodist Church is celebrating its 150th anniversary in fall 2011, it is difficult to determine the exact date of its founding, and it is likely much older. Methodists were meeting in the area prior to 1854, the year David L. Beadle platted the town. A few pioneer families were in the vicinity, two of which were William and Caroline Fricke (left) and Fred and Elizabeth Fricke (below). They, along with the Andrew Uhe family, built dugouts in the side of hills, which they opened to those wishing to congregate as Methodists. They were a part of the Omaha Mission, and Rev. J.P. Miller came from Omaha to conduct services in German. The congregation carried on as a mission church until 1884, when it became a one-point charge. (Both, courtesy of St. Paul's Methodist Church [St. Paul's].)

Andrew and Fredericka Uhe were among the founding families of St. Paul's Methodist Church, and their descendants still attend. Their dugout was also used as a meeting place until the attendance made it impossible. The small congregation began meeting in the newly constructed Sautter School, situated close to the John Sautter farm, just north of town. Though the Sautters were of the Lutheran persuasion, they had donated land for the school and a cemetery, which was originally for Lutherans until it was opened up to the general population. It is now called the Papillion Cemetery. (Both, courtesy of St. Paul's.)

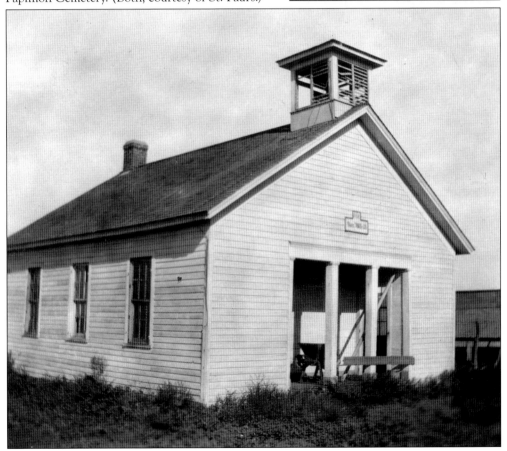

In 1875, the congregation had grown to around 50 members, and the first church and parsonage were built at 324 South Jackson Street. Reverend Brinkmeyer was among the ranks of many pastors in the church's early years. The small bell used in the church was a part of the Bellevue Mission and is considered the oldest bell in the state. In 1900, Fred and Elizabeth Fricke donated a larger bell, and both bells are still in the new building today. In 1917, the congregation began modifying the church building, which was heated by a stove in the center of the sanctuary. They lifted the structure and added a basement, which allowed for an auditorium, kitchen, and men's lobby room as well as a furnace room and indoor restroom. (Left, courtesy of St. Paul's; below, courtesy of Jim Miller.)

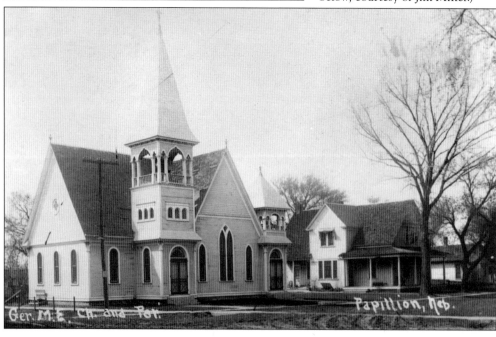

These photographs are a ticket back in time to when the Methodists worshiped in the old sanctuary. The large crowds caused the congregation to realize the need for further growth, and in 1958, the congregation purchased land north of the church, which was developed in 1978 as the north addition. The new construction included a kitchen, Sunday school rooms, and fellowship hall. In the 1990s, the church purchased land west of the site and also land and a house on South Madison Street, which gave the church the entire block on which to grow. In 2001, ground was broken for a 30,000-square-foot addition. St. Paul's celebrates its 150th anniversary in fall 2011. (Both, courtesy of St. Paul's.)

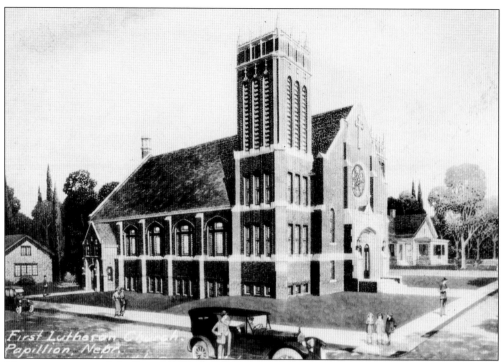

The congregation of the First Lutheran Church was organized in 1876. William Sander offered that members could gather in the hall above his store without any charge on Sunday afternoons. They met biweekly, and services were conducted in German. William Huesemann became the first resident pastor in 1884. Classes were taught to children in the church basement until a two-room school was built across the street in 1918. Classes were in German until the close of World War I, when it became unpatriotic, and this distinct part of Papillion's culture began to fade. In 1922, the congregation began construction on a brick building, and the church moved to the other side of Washington and Fourth Streets. The cornerstone was laid in 1925 following completion of the building. (Above, courtesy of Brad Stephens; below, courtesy of Jim Miller.)

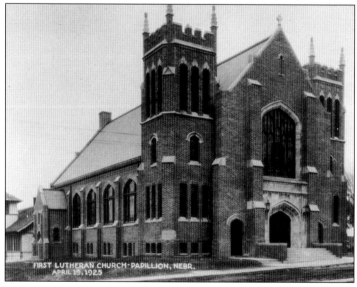

The first services of the Evangelical Lutheran Frieden's Church were held in the German Methodist sanctuary in 1908. Jacob Lutz donated the land, and a building was dedicated in December of that year. The pews and the bell were also given by Jacob Lutz and are present in the building today. (Courtesy of Trinity Evangelical Lutheran Church.)

In 1958, the congregation of the Frieden's, now Trinity Evangelical Lutheran Church, embarked on a project that tested their commitment and renewed their pioneering spirit by building a new church with volunteer labor. Wesley Turtscher (pictured), a contractor by trade and generous citizen by nature, gave guidance and leadership to the project. Soon, the ground was excavated with the help of Floyd Trumble who owned digging equipment, and the basement was soon completed. The building was dedicated in 1960. (Courtesy of SCHS.)

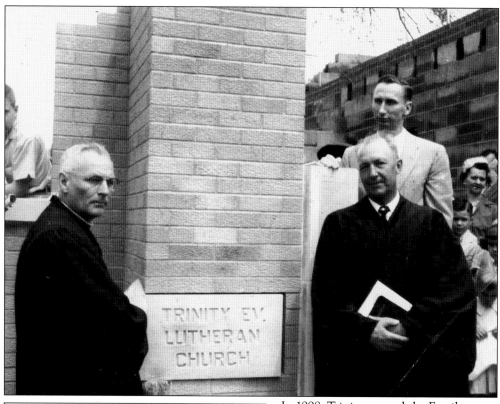

In 1998, Trinity opened the Family Life Center and, in 2000, launched Trinity Village as a retirement facility. Both are located west of Washington Street on Lincoln Street. Contemporary church services are held at this site. (Courtesy of SCHS.)

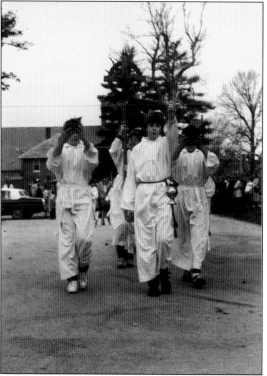

A procession of altar servers leads the congregation in celebration on Easter Sunday at St. Columbkille Catholic Church. The church is one of the most widely attended parishes in the metropolitan area. (Courtesy of St. Columbkille.)

In 1863, Catholic families began settling in the Papillion area. The first services were held in the railroad section house or in private homes. In those days, the priests served more than one parish. Fr. John Curtis was one of the earliest pastors to say mass in Papillion. In 1878, two lots were bought from David Beadle, and the small parish built its first church. In 1897, Rev. Henry Hoheisel arrived and began raising funds to build a parsonage, which was completed in a matter of three months. By the early 1900s, the congregation incorporated and officially became St. Columbkill's, a slightly different spelling from today's St. Columbkille. In 1916, the church experienced further growth and decided to build a parochial school, which became Sacred Heart Academy. (Both, courtesy of Brad Stephens.)

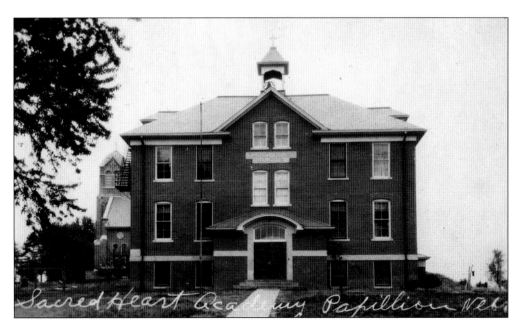

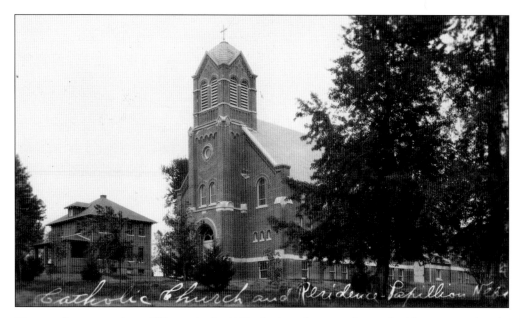

*Catholic Church and Residence Papillion Neb*

The parish grew to about 250 people. In 1922, the board met to discuss building a new church. In 1923, the church sold the parsonage and the three lots that are behind today's city hall and purchased property at Sixth and Washington Streets. The new brick building was dedicated in 1927. Eight art-glass windows were installed, making the sanctuary a beautiful and inspiring place of worship. The Great Depression hit parishioners hard. During this time, the main source of revenue from the parishioners was called "rent a pew." This payment secured the giver's name on a pew that was reserved for his or her family on Sunday. In 1939, Fr. Clarence Trummer became the pastor. (Above, courtesy of Brad Stephens; below, courtesy of St. Columbkille.)

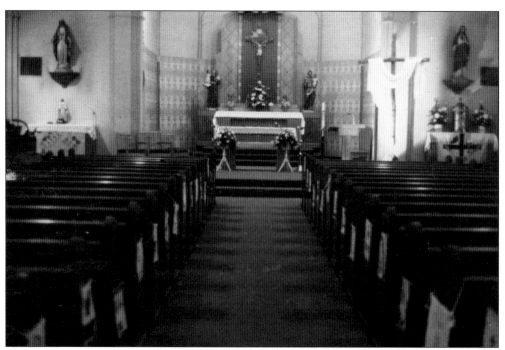

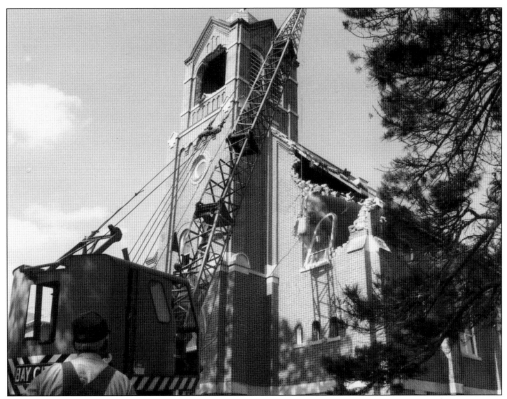

In 1979, Father Steinhausen and the parish council appointed Richard Scheer, Frank Bianco, Betty Hezel, Mike Kinney, Dave Koenigsman, Eldon Lauber, Tom Satchell, Al Schmid, and Bernard Schram as a building committee for a new church. Land at the current site was purchased from Jane Hogan, and the church hired Petersen Brothers Construction Company of Omaha as builders. The old A.W. Clarke home that originally faced Sixth Street was turned to face Eighty-fourth Street and was placed next to where the new church was going to be built. It is the church administration building. (Both, courtesy of St. Columbkille.)

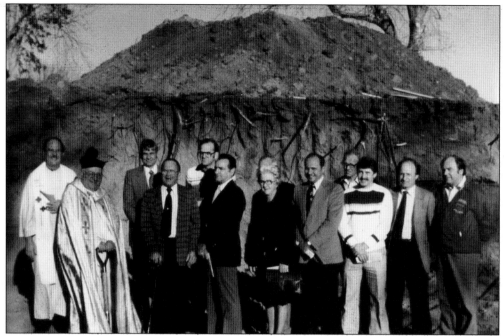

On November 9, 1980, St. Columbkille broke ground for a new church. From left to right are Fr. Harry Buse, assistant pastor; Fr. Robert Steinhausen, pastor; Eldon Lauber; Charles Crum; Dave Koenigsman; Mike Greco, mayor; Bernard Schram; Betty Hezel; Frank Bianco; Vince Petersen, contractor; Mike Kinney; Gary Bowen, architect; and Al Schmid. (Courtesy of St. Columbkille.)

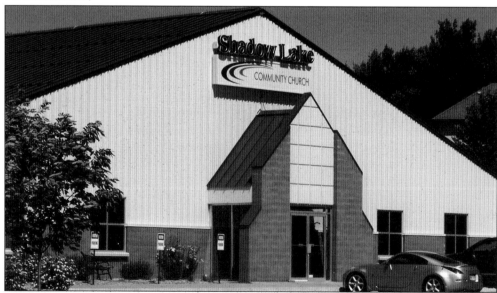

In 1997, a combined group of people from Millard Bible Church and Papillion assembled to form Rolling Hills Church. In 1998, members obtained a building near Seventy-second Street and Highway 370, and for the next six years, Rod Anderson served as pastor. In 2004, Brian Classen came to serve as pastor and was instrumental in changing the name to Shadow Lake Community Church. The current pastor is Lance Burch. (Courtesy of Shadow Lake Community Church.)

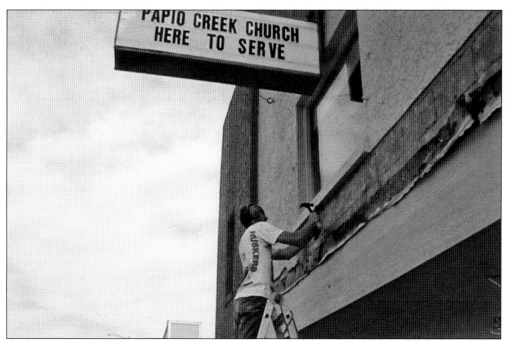

In 2003, a group of 50 people from the Westwood Church in Omaha decided to branch out into Papillion as the Papio Creek Church. The old Papio Theater was purchased a few years earlier and transformed into a concert venue, and the Papio Creek Church rented the space to hold services. The former Masonic lodge next door is also used by the church. The church has made many improvements to the properties in order to better serve the community. Darrin Kimpson and his wife, Pam, are renewing the Papillion pioneer spirit as they groom the church to become an important part of the community. (Both, courtesy of Papio Creek Church.)

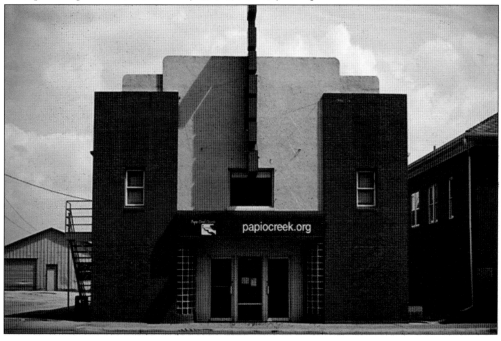

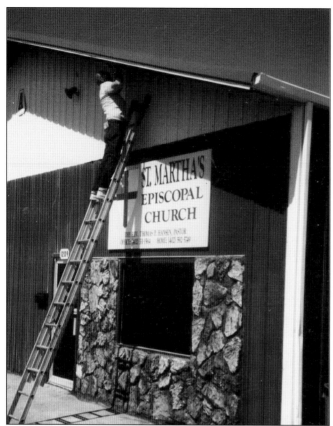

St. Martha's Episcopal Church had an unusual beginning. In 1992, a group of individuals interested in building an Episcopal church in Papillion decided to gauge interest through an information campaign by making phone calls. Leo Kluch set up a phone bank, and volunteers began spreading the word and determining interest. After thousands of calls went out, the group determined there was enough interest to establish a church. The first service was held on September 8, 1992. Rev. Tom Hansen was the first rector. (Both, courtesy of St. Martha's.)

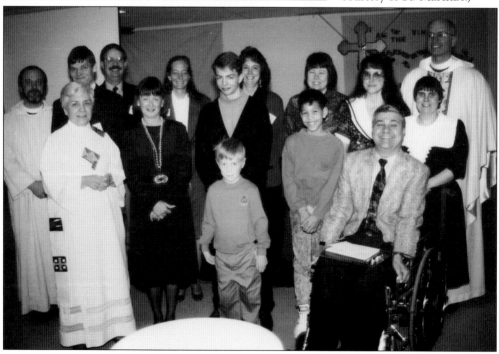

*Four*

# THE METAMORPHOSIS BEGINS
## FROM BUTTERFLIES TO MONARCHS AND TITANS

The community of Papillion experienced periods of rapid growth that required the school district to constantly assess the adequacy of its educational facilities. Pauline Carpenter is believed to have been the first teacher in the Papillion School District, when students met in the home of Pauline Thompson. In 1873, a wooden structure was built on the south side of the creek, which became Papillion's first schoolhouse. This school was replaced in 1875 by a new brick building.

With the strong leadership of district superintendents, school boards, and, most importantly, teachers, the public schools of Papillion and La Vista have become illustrious examples of high-quality education that attracts people to the community. Since its beginning, the school district has grown from a single brick building to two Class A high schools, an alternative school, two junior high schools, and 14 elementary schools. The Papillion-La Vista School District consistently tests at or above required levels and has an impressive graduation rate, with a good number of scholarships awarded to graduates.

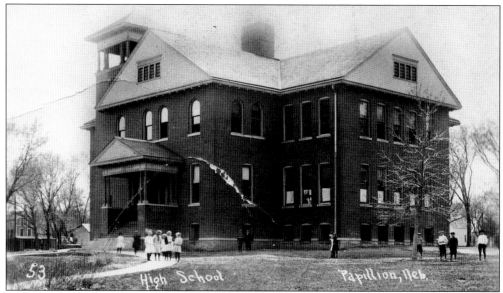

An overcrowded frame schoolhouse proved not to be enough in 1874, when attendance reached 62 students. The *Papillion Times* petitioned the town to construct a building with primary and advanced rooms. With over 50 children in daily attendance, the editor said, "You may as well undertake to shampoo an elephant with a thimble full of soapsuds, as to attempt to successfully and beneficially conduct a school of fifty ungraded pupils all in one room." In 1875, a schoolhouse was built with bricks manufactured at the Papillion brick factory, just south of the location of the school. The school board issued bonds to secure $3,500 for the construction. A.E. Lake was the first principal in the new school building. (Above, courtesy of PAHS; below, courtesy of Papillion-La Vista Public Schools [PAPLV].)

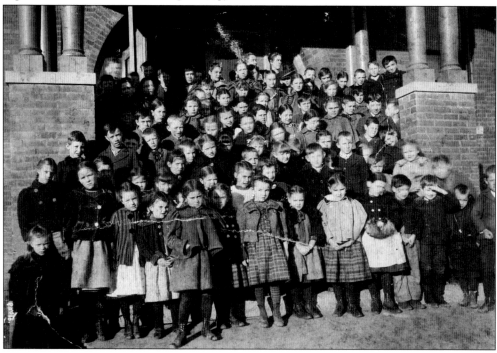

The position of county superintendent of schools was decided by election. The superintendent was a political figure and campaigned for the position throughout the county. He was responsible for choosing curriculum and hiring teachers as well as overseeing the general operation of all the district schools. John Speedie was superintendent in the 1890s. (Courtesy of SCHS.)

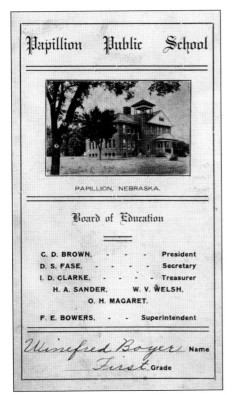

Winifred Boyer earned generally high marks on this report card. Unfortunately, the year she attended the first grade cannot be determined. She was graded in arithmetic, reading, penmanship, and citizenship, in which she earned high marks for being kind to her classmates. (Courtesy of PAHS.)

Cordelia Gramlich Borman made her place in local history in 1916 by becoming the first woman elected in Sarpy County to the public office of county superintendent, four years before the passage of women's suffrage. She graduated from Papillion High School in 1909 and began teaching at the Frazier Rural School, District 19. She used her income to finance classes at Peru College, where she received a Life Teaching Certificate in 1912. Jobs at Bell, District 18, and Papillion, District 27, preceded her decision to run for county superintendent of schools in 1916. After the purchase of a 1916 Ford Model T, she began to campaign across 250 square miles of Sarpy County. With the support of *Papillion Times* editor G.P. Miller, she won the election on the Democratic ticket. The total cost of the campaign was $49. She married Herman Borman (with her below) in 1919. (Both, courtesy of Harold Borman.)

Prof. Ira Lamb, the school superintendent in the early 1900s, moved to Papillion from Hopper, Nebraska, to assume his duties in Sarpy County. His son Fred Ray Lamb and daughter Nellie were longtime residents of Papillion. Another son, W.H. Lamb, who was a photographer for a magazine in Virginia, took this picture of his father. (Courtesy of PAHS.)

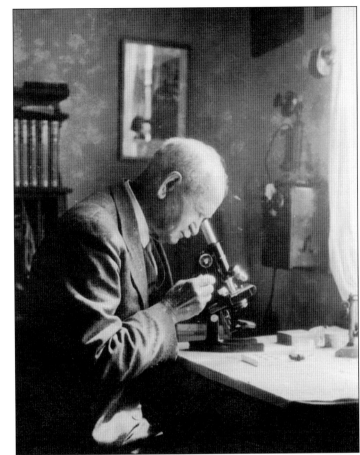

This 1913 field trip actually took place in a field where students studied the subject of botany with Professor Lamb. The photograph was found in an album belonging to Pearl Lamb, the wife of Fred Ray Lamb, that was left to the Papillion Area Historical Society. (Courtesy of PAHS.)

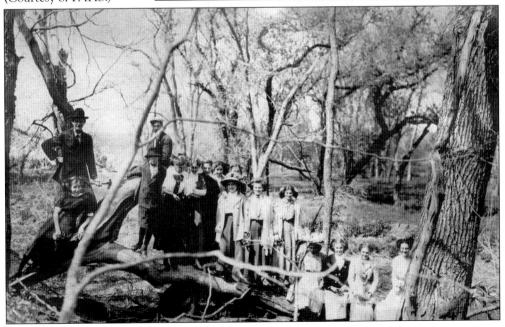

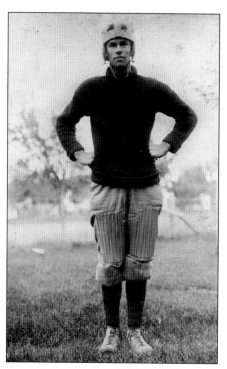

This 1913 photograph is of Fred Ray Lamb in his Papillion football uniform. The team was organized but did not fare well in competition due to the size of the competitors. In 1923, a loss to Ashland ended in a humiliating score of 102-6. In 1924, the team was disbanded for a lack of interest. (Courtesy of PAHS.)

This photograph is of the students of the Sarpy Center School, which was located south of Papillion. Sarpy Center was competing to become county seat in 1875 when Papillion won out in an unexpected turn of events. It is interesting to note the number of African American students in the class at this time. There were African American families living in the area, though the number was low. (Courtesy of SCHS.)

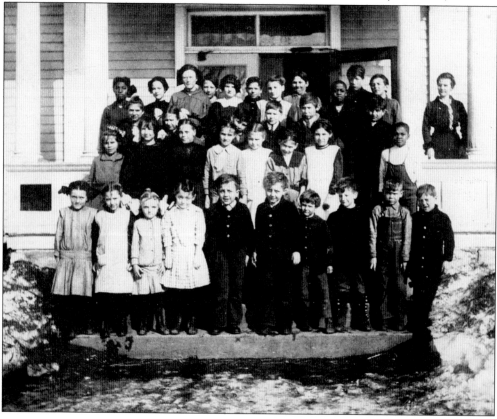

This image of a 1904 souvenir is graced with a photographic insert of teacher Gertrude Schobert. On the inside of the pamphlet, she jots the age of each of her students beside their names. Fred Whittmus and Ernest Wiess Sr. were also directors of the school at various times. In 1904, the teacher earned about $38 per month and had to hire a custodian or be responsible for the school housekeeping. Each morning, she carried water into the school and stoked the fire using corncobs to ignite the coal, which she carried from the coal shed. (Both, courtesy of PAHS.)

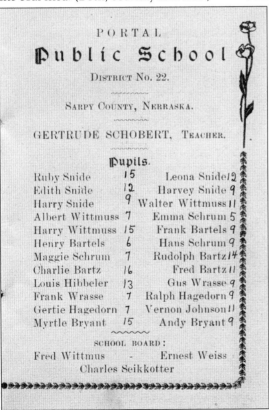

PORTAL

# Public School

DISTRICT No. 22.

SARPY COUNTY, NEBRASKA.

GERTRUDE SCHOBERT, TEACHER.

## Pupils.

| | | | |
|---|---|---|---|
| Ruby Snide | 15 | Leona Snide | 12 |
| Edith Snide | 12 | Harvey Snide | 9 |
| Harry Snide | 9 | Walter Wittmuss | 11 |
| Albert Wittmuss | 7 | Emma Schrum | 5 |
| Harry Wittmuss | 15 | Frank Bartels | 9 |
| Henry Bartels | 6 | Hans Schrum | 9 |
| Maggie Schrum | 7 | Rudolph Bartz | 14 |
| Charlie Bartz | 16 | Fred Bartz | 11 |
| Louis Hibbeler | 13 | Gus Wrasse | 9 |
| Frank Wrasse | 7 | Ralph Hagedorn | 9 |
| Gertie Hagedorn | 7 | Vernon Johnson | 11 |
| Myrtle Bryant | 15 | Andy Bryant | 9 |

SCHOOL BOARD:

Fred Wittmus  -  Ernest Weiss

Charles Seikkotter

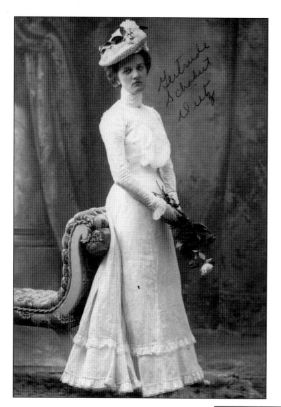

One of the first teachers at the Portal Schoolhouse was Gertrude Schobert Dietz, who taught in the early 1900s. At that time, women were hired as teachers as long as they were single and had no children and earned less than men who were hired for the same position. (Courtesy of PAHS.)

The Papillion Area Historical Society raised funds to move the old Portal Schoolhouse next to the Sautter House across from the city hall. Once it was abandoned as a school in the 1980s, the building was subject to vandals. The old bell was stolen, and the building was badly damaged but was successfully moved to its current location. (Courtesy of PAHS.)

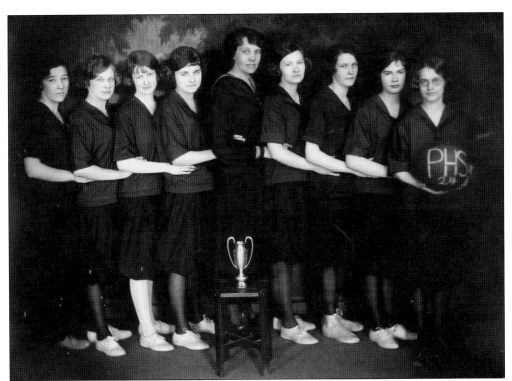

Basketball was a popular sport in Papillion's high school, which was open to both men and women. Papillion was successful in securing several state championships and played its games in the auditorium at Bell's Hall as well as in the gymnasium at the high school once it was built. Those in this photograph of the women's team are, from left to right, Martha Zweibel, Stella Fase, Helen Spearman, Pearl Keefer, coach Estella Krejci (married G.P. Miller), Noreen McCoy, Susie Arbuthnot, and Amelia Magaret (captain). Noreen McCoy scored an impressive number of points in a game against Millard in 1924. Out of the 44 points scored, she made 34 of them. The names of the 1930 men's team, whose uniforms are appliquéd with large butterflies, are not available. (Both, courtesy of PAPLV.)

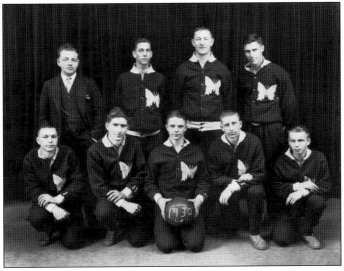

Before 1923, school sporting events and performances took place in one of the auditoriums around town. Basketball games were played at Bell's Hall, which was not ideal. Coupled with the need for more educational space, the school board built an addition to the school that included a gymnasium-auditorium, classrooms, and a science laboratory. (Courtesy of PAPLV.)

In 1926, the number of automobiles in town increased, but horse-drawn buggies were still a common sight. Fashion was taking a dramatic turn as hemlines moved several inches upward and beaded necklaces draped to the knees. This group of junior and senior Papillion High School students has come out in high fashion for the prom, which was held in the school's new gymnasium. (Courtesy of PAPLV.)

**PAPILLION**

HIGH SCHOOL BOYS

**Basket Ball Team**

**CHAMPIONS**
CLASS G

**State Basket Ball Tournament**

**Lincoln, Nebraska,**

**March 11, 12, 13, 1926**

The Papillion men's basketball team was victorious in the state basketball tournament of 1926, held in Lincoln during the second week in March. Coach Beachy led the Monarchs to victory. At the time, basketball and baseball were the only two sports played at Papillion. (Both, courtesy of PAHS.)

## Tournament Record

Papillion 13, Paxton 9

Papillion 15, Big Springs 13

Papillion 24, Ainsworth 9

Papillion 21, Oakdale 15

## The Team

| | |
|---|---|
| Ernest Magaret, Capt. | F |
| Herman Haeberlein | F |
| Edwin Hagedorn | F |
| Alvin Huebner | F |
| John Beadle | C |
| Wendel McManamy | G |
| Philip Steyer | G |
| Harvey Arbuthnot | G |

E. L. Beachy, Coach

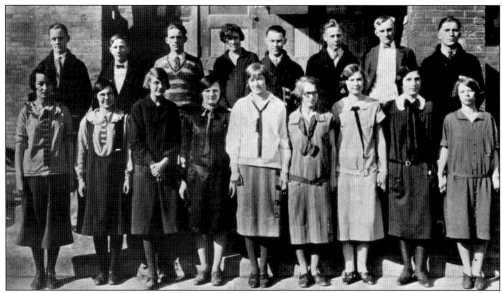

The 1926 staff gathers for an annual photograph. In no particular order are Jesse Reinking, Wendell McManamy, Helen Spearman, Beulah Ross, Dorothy Fase, Lillian Cordes, Louis Eitelgeorge, Gretchen Sander, Stanley Beerline, Mercedes Schaab, Carl Fricke, Alvin Huebner, Elizabeth Sprague, Philip Steyer, John Beadle, Amelia Magaret, and Helen Frazeur. (Courtesy of PAPLV.)

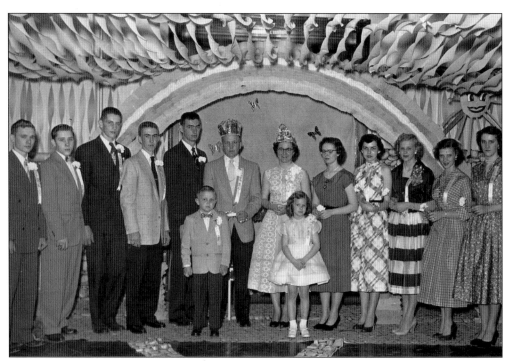

Those chosen as royalty at the 1953 athletic banquet are, from left to right, ? Moore, Rodney Olson, Richard Erich, Don McKernan, Dale Hoge, Robert Gloe, Elaine Haug, Patricia Baker, Clarlene Peters, Joyce Harder, Sandra Cordes, and Dorothy Becker. The pages in the front row are, from left to right, Larry Gloe and Diana Denker. (Courtesy of PAPLV.)

Alice Allen taught a combination class of fifth- and sixth-grade students in Papillion. All grade levels met in one building. In the early 1900s, Papillion had the only four-year high school in the county, and students stayed in a boardinghouse, which is now the Kahler-Dolce Funeral home on Washington Street. (Courtesy of SCHS.)

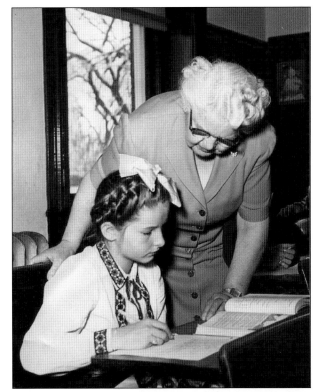

The Papillion High School band practices on the neighborhood streets for an upcoming performance. Over the years, the bands have extended their talents in marching band competitions and have travelled overseas to perform in such places as England and Austria. (Courtesy of PAPLV.)

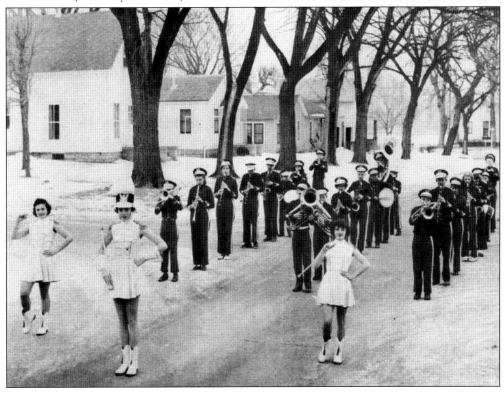

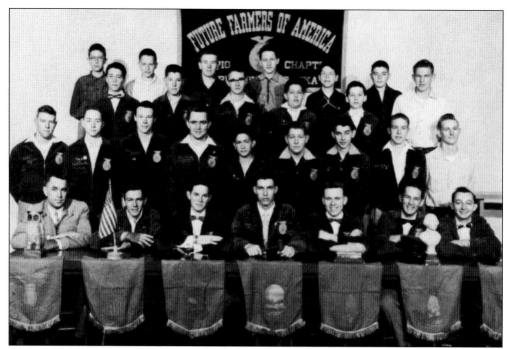

The Future Farmers of America is an important organization in Papillion because of its strong agricultural ties. These boys are likely sons of farmers. Members benefitted from the club's activities, and some got the chance to represent the school at Cornhusker Boys' State, which was held yearly at the state capital. (Courtesy of PAPLV.)

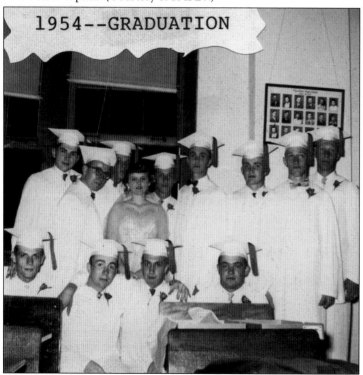

This 1954 graduating class does not compare in numbers to the hundreds of students who graduate from the district today. Here, they pose in the corner an upstairs classroom in the old brick schoolhouse. (Courtesy of PAPLV.)

Supt. Harlan Metschke poses for a photograph after the time capsule was removed from the cornerstone of the old Papillion High School. The capsule included three 1922 *Papillion Times* newspapers; a copy of a bond petition, dated June 15, 1922; and a ballot record of the contested $30,000 bond issue that built the addition to the school. Exactly 117 voters were in favor, with 116 against. It also included a program of the cornerstone laying in 1922. (Courtesy of PAPLV.)

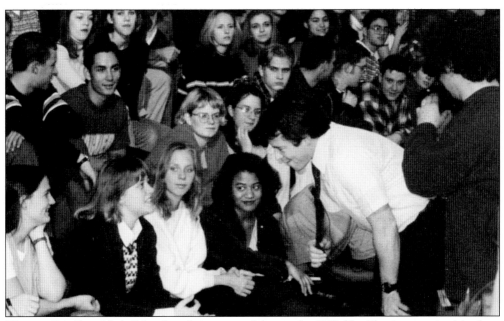

The new Papillion High School made its screen debut in the 1999 film *Election*, starring Matthew Broderick, Reese Witherspoon, and Chris Klein. Here, students at the school meet Broderick up close in a school assembly, where he took the time to answer questions. (Courtesy of PAPLV.)

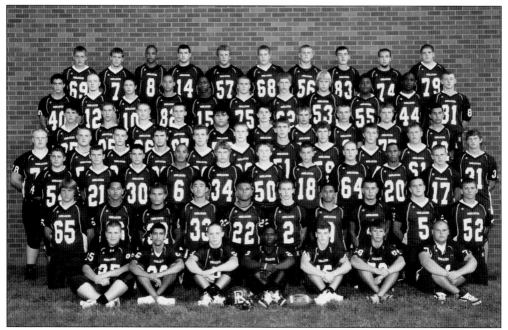

The Papillion-La Vista Monarchs consistently produce teams with competitive edges that have played at the top of their division in every sport over the years. Here is the 2010–2011 Papillion-La Vista Monarch football team. (Courtesy of SCHS and Hassel Photography.)

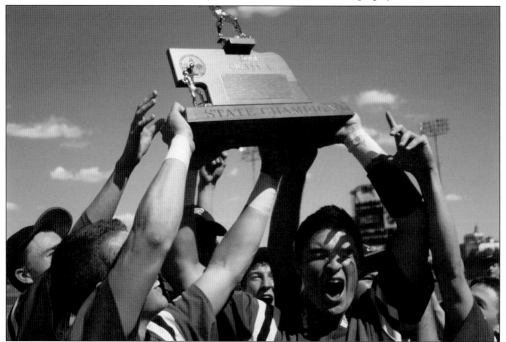

In August 2003, the Papillion-La Vista South High School opened south of town; its teams are known as the Titans. Students at the school immediately made their marks in academics, fine arts, and sports. In 2011, the Titan baseball team won a second consecutive Class A state title. (Courtesy of the *Papillion Times*.)

*Five*

# QUENCHING THE WILD
# OF THE WEST
## PAPILLION'S PUBLIC SAFETY

In 1898, Deputy William Liddiard from nearby Springfield asked Sheriff Whitney to allow him a space at the courthouse to his display his collection of guns, knives, hatchets, and clubs he confiscated from "common thieves and felons." The assortment included a hatchet used in the Chop House Riot in Omaha in the early 1890s. The museum drew crowds for weeks and is an example of the Wild West beginning of Sarpy County.

Those were the days when the streets in Papillion were dusty roads, and each town had its own marshal and bucket brigade. Fire was a fearsome foe that was hard to prevent because light came from lanterns and cooking was done in woodstoves. In Papillion, every able-bodied man was expected to answer the bell that rang an alarm to help fight fire. A *Papillion Times* article from 1909 says that the town's first order of fire apparatus included a 50-foot extension ladder and 15 buckets. A hose wagon was purchased around 1910, and old photographs prove that fire hydrants were in place about the same time. Fire, however, was not the only safety concern in Papillion.

As in any community, Papillion had its share of thuggish felons who preyed on the innocent. Prohibition was a miserable failure and produced more crime than most communities could fight. Bootlegging and rum-running were as much a part of the Papillion scene as in any other community. As Papillion grew, so did the need for proper fire and police protection.

Papillion's fire and police departments have grown to become shining examples of professionalism and community leadership that display an intense commitment to education and practical training. Papillion is in safe hands.

Over the years, the Papio Bridge had many looks. In the early days, it was a basic board span, and after a flood took it out, the town built a trestle bridge in its place, which was replaced in 1922 with a concrete bridge adorned with electric streetlights. In 1959, however, heavy rain of up to 10 inches poured over the town in August, and the creek rose to dangerous levels within hours. Firemen began sandbagging a levee, but Mother Nature had her way, and the Papio Creek spilled into the streets of Papillion with damaging results. The beautiful bridge began to take a beating from flood debris, and before long, the footings collapsed, and the concrete bridge went plummeting to its destruction. A temporary span was built at First and Jefferson Streets until a new Washington Street Bridge was constructed. (Both, courtesy of SCHS.)

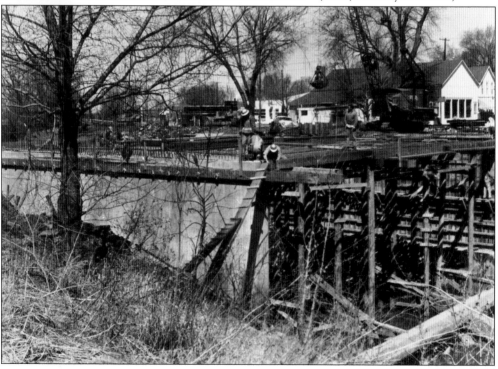

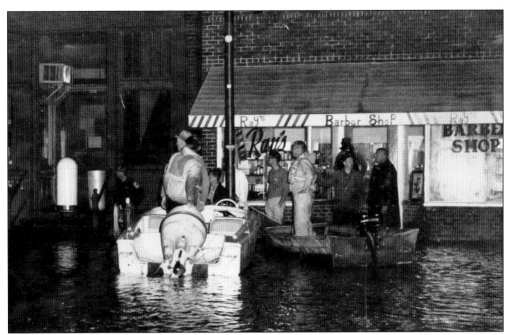

Papillion was again visited by unwelcome floodwaters in 1964 in what was reported to be the worst flood in town history. The Papillion Volunteer Fire Department came out in boats to rescue people caught off guard in the apartments above or in businesses below. Two Papillion youths, Don Ingram and Oscar Cronwall, barely survived by clinging onto branches in the swiftly moving water. Large hail and several inches of rain caused the water to rise to the front steps of the high school, located where the Central Office is today. At one point, a fireman's boat went out of control and broke through the window at Paul's Drugstore. Seven people along the Papio Basin lost their lives, but all were spared in Papillion. (Both, courtesy of Bev Higgins.)

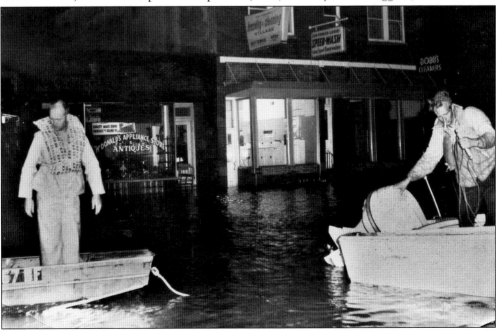

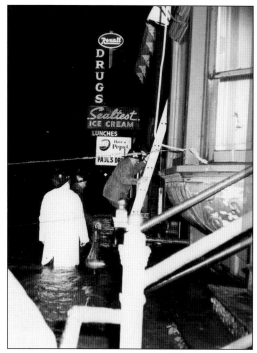

A fireman climbs a ladder to reach trapped victims during the 1964 flood. From this flood came talks of building a levee. On the other side of the bridge, the Papio Theater became submerged. Ironically, the movie poster in the display was for *The Incredible Mr. Limpet*, a story about a man who wished to be a fish. It is unclear if the theater was able to show the film after pumping out the water that rose over the top of the theater seats. Once the crisis was over, the town thanked the volunteer fire department by giving donations. (Both, courtesy of Bev Higgins.)

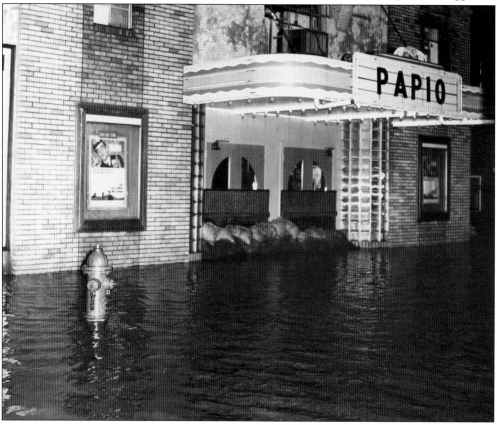

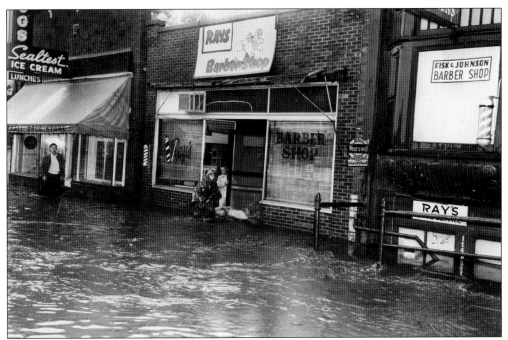

Ray Lemke owned the A.W. Clarke Building (right) and the barbershop (center). Below the potbellied bay window with the Fisk and Johnson Barber Shop sign is a basement, which Ray called the "Stump Room." It was here that the *Papillion Times* had its offices in the early 1900s, and, unfortunately, the newspaper's archives were lost due to flooding. (Courtesy of PAHS.)

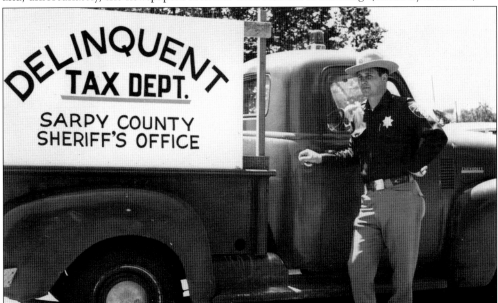

Sheriff Richard Whitted is one of those colorful characters who make Papillion history an interesting read. He was elected to office in 1962, and one person reflected that he was a lawman out of the Wild West, living outside of his time. Several have viewed this photograph, but no one is able to explain its nature, but one thing is clear in Sarpy County—paying taxes was mighty important. (Courtesy of SCHS.)

Joseph "Jerry" Strawn served Papillion Volunteer Fire Department in the offices of chief, president, and treasurer and was fundamental in raising the funds necessary to build the new fire department. In 1983, the town was rocked when citizens heard that he passed away from a sudden heart attack. Jerry Strawn was a highly intelligent, loving father and husband who was committed to the community he served. (Courtesy of Jeff Strawn.)

In Papillion, the Lions Club spaghetti feed is the first sign of spring, and the fire department's pancake breakfast rings in the autumn season. This photograph is of a pancake breakfast in the 1940s. At the far right is Jerry Strawn. (Courtesy of Bev Higgins.)

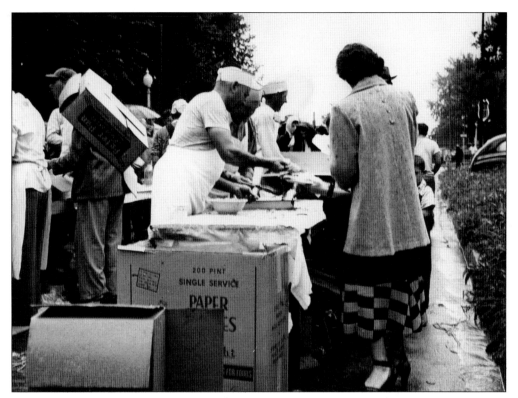

In 1947, the Papillion Fire Department brought the community together for a free barbecue to celebrate the arrival of its new American LaFrance fire truck. Parades and other activities made the day an event the community continued and called "Papillion Days." Later in the year, the Papillion Volunteer Fire Department added "Inc." to its name after it incorporated. (Both, courtesy of Bev Higgins.)

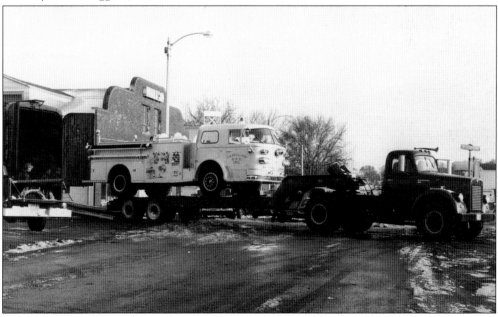

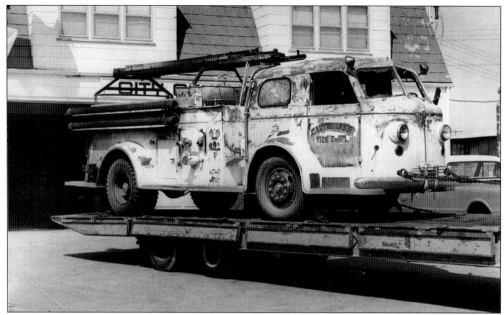

The fire department sold the 1947 LaFrance fire truck to the Carter Lake Volunteer Fire Department not many years after it was purchased. In an ironic twist of events, the truck was returned to Papillion after it caught on fire in the Carter Lake fire barn. The truck was badly damaged but was able to be restored. The Uhe Auto Shop did most of the restoration on the truck. (Courtesy of Bev Higgins.)

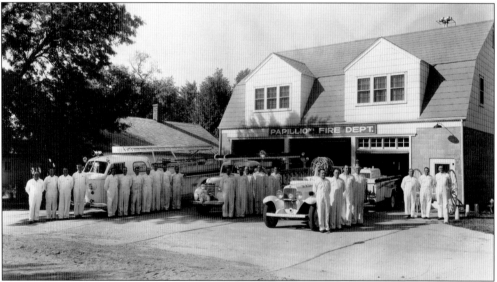

In 1942, a meeting was held to formally organize a volunteer fire department. A decision was made to appoint 25 members, who included seven officers and equipment manager John Evers. The officers were Paul Hellbusch, fire chief; H.J. Arbuthnot; Jim Poole; William Huebner; J.L. Klingeman, president; and Otto Denker, secretary. General members were Al Olson, Tony Bucher, Donal Horn, Chester Denker, Blondy Ruff, Bob Kok, John Daup Jr., Howard Cordes, Louis Zeeb, H.J. Lutz, Don Reis, Cliff Hanes, George Slimm, Fred Schutz, George Beerline, H.W. Eaton, and Car Christiansen. (Courtesy of Bev Higgins.)

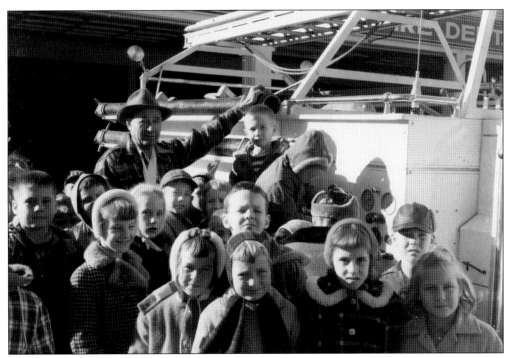

This happy group of school-age children is getting the chance to see the fire trucks up close. Papillion Fire Department has a long history of educating young people about fire safety and prevention. (Courtesy of Bev Higgins.)

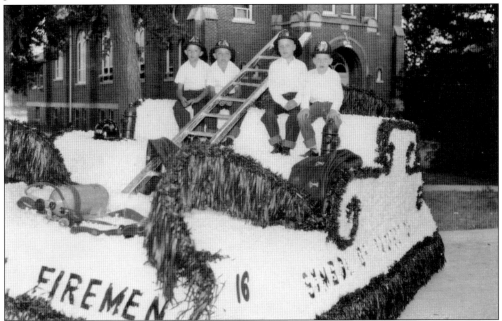

Many a young lad watched the men on the fire department with curiosity and awe in hopes of becoming a hometown hero. These young men live out their dream if only on a Papillion Days float. The church in the background is St. Columbkille, which was torn down to make room for St. Columbkille as it is known today. (Courtesy of Bev Higgins.)

The 1910 hose cart has been a familiar sight in Papillion's parades. In early days, it might have been pulled by horse or used as a handcart depending on the distance of the fire. Among the activities held at the Papillion Days celebration are water fights between area volunteer fire departments. One game included a bucket hung from wire that was strung between two poles. Battling in the opposite direction, two fire teams had to push the bucket across their finish line before the other team. Children loved the game, which was particularly refreshing on a hot summer day. (Both, courtesy of Bev. Higgins.)

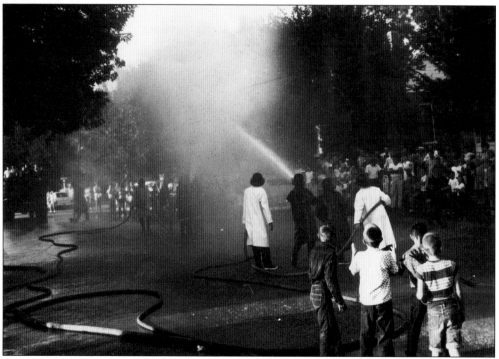

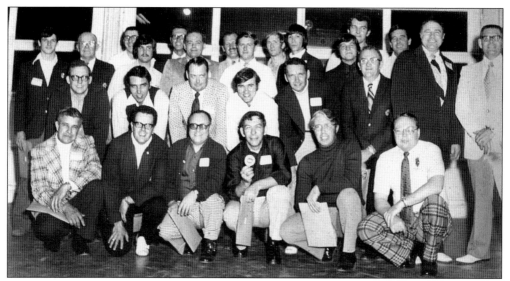

This well-known group of volunteers poses after receiving training. Those pictured are, from left to right, (first row) E. Remmers, R. Higgins, J. Thernka, J. Kolder, B. Beerline, and B. Olson; (second row) R. Zeeb, A. Richards, J. Maze, R. Thorpe, M. Dineen, H. Cook, and two unidentified instructors; (third row) J. Strawn, P. Hellbusch, J. Schendt, D. Langfield, D. Grube, C. Dierks, W. Kalal, and B. Wagner; (fourth row) V. Krautfremer, F. Wiess, B. Jorstadt, C. Benson, and R. Schmidt. (Courtesy of Bev Higgins.)

In August 2009, the Papillion Police Department suffered a tragic loss. Former patrol sergeant Thomas Welch (right) passed away after a short illness, leaving behind his wife, Wendy, and daughter, Megan. Tom was instrumental in the planning and creation of the Papillion Police Department Special Weapons and Tactics (SWAT) team and was a good friend to all. He was known for his quick wit and humor and will be sorely missed. Current police chief Leonard Houloose is on the left. (Courtesy of Wendy Welch.)

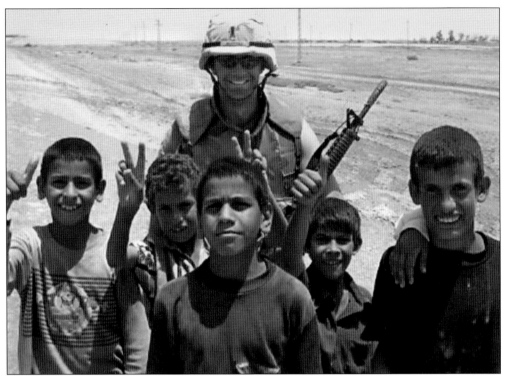

Papillion police lieutenants Orin Orchard and Chris Whitted perform double duty as Army Reserve officers. Each man has completed tours overseas on multiple occasions and served in leadership roles in assistance to foreign governments. Lieutenant Whitted (above) is a direct descendant of Sarpy County pioneer Joseph Whitted. He served at Camp Anaconda in Ad Dujayl, Iraq, where he supervised a fire detachment. In the 2008 photograph below, Lieutenant Orchard (third from left) served at Camp Buca in Iraq. He has served in four overseas tours while working as an officer in Papillion. (Above, courtesy of Chris Whitted; below, courtesy of Orin Orchard.)

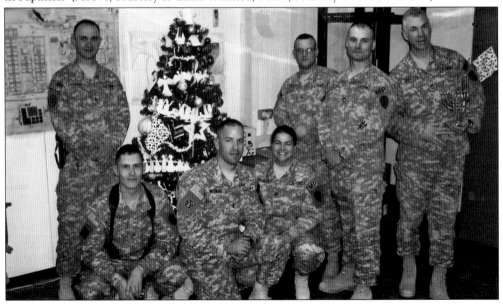

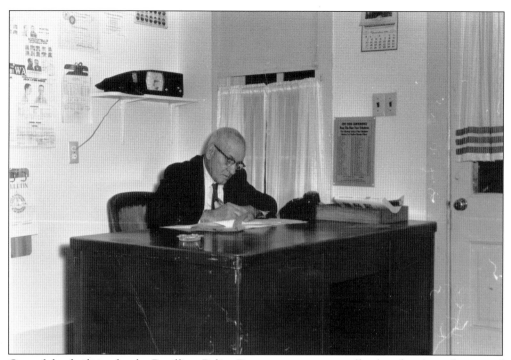

One of the facilities for the Papillion Police Department was a small, white house in the area of the American Legion Club on Lincoln Avenue. In this 1964 photograph, justice of the peace Bill Linder stops by the department to sign some papers. On the walls are FBI wanted posters and a certificate of completion at the Law Enforcement Training Center. (Above, courtesy of SCHS; below, courtesy of Papillion Police Department.)

The first Papillion police officer was Harry Steeden. He was promoted from village marshal on April 29, 1952, when the village board of trustees dramatically adjourned and then reconvened as the city of Papillion after the census reported the population to be that of a second-class city. The population was 1,032, and Carl Stamm was the first mayor under the new status. The above photograph is of the 1997 Papillion Police Department. Gathered in the photograph below is a group of men who have all served as police chiefs. From left to right, they are Ervin Portis, John Ernst, Dan Hoins, current chief Leonard Houloose, Fred Biesecker, Steven Engberg, and Ronald Easley. (Both, courtesy the City of Papillion.)

In 1972, plans were being discussed for relocating the Doctor's Hospital in Omaha to Papillion at Eighty-fourth Street and Highway 370. In 1973, the first bond issues were sold, and in 1976, Midlands Community Hospital opened in Papillion on the former site of the Condon farm. C.G. Smith (pictured) owned the property and made a major grant of the land to the hospital; the rest was purchased from Smith. (Courtesy of MCF.).

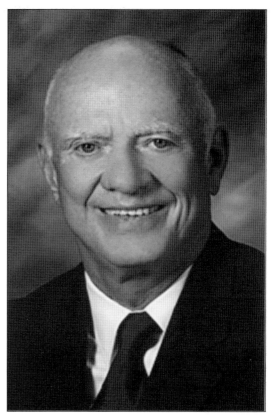

Gene Tschida, the president of Bank of Papillion and treasurer of the hospital board of trustees, was appointed as coordinator of fundraising in the hospital service area in fall 1974. This area included all of Sarpy County and portions of Cass and Saunders Counties. (Courtesy of MCF.)

Before ground could be broken for the construction of the hospital, a house owned by the Harvey Shanks family had to be moved. Excitement grew in the community as the landscape began to change and the hospital emerged. After the hospital opened in 1976, physicians were not using the institution, and talk of selling or closing the hospital began. The Northwestern National Bank assumed receivership, and Moe Miller was appointed as receiver. Under Miller's guidance, receivership was lifted in 1985. In 1997, Midlands joined Alegent Health, one of the nation's top health care organizations. (Above, courtesy of MCF; below, photograph by Miriah Anderson.)

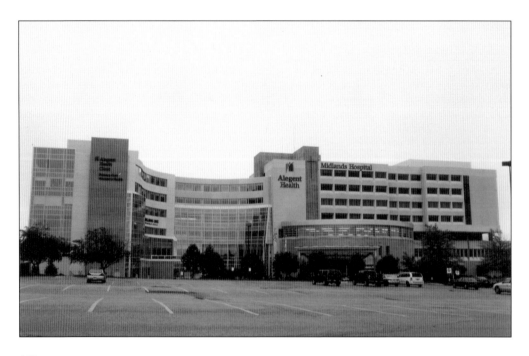

# *Six*

# A City With a Future
## America's Fifth-Best Place to Live

Throughout its history, Papillion has been known as a fun place to live. The early pioneers enjoyed performing for the public in organized groups, like the Home Town Talent Drama Club and the Papillion Cornet Band. A shinning example of joyful festivities in Papillion was the 1923 town dance that celebrated the opening of the new courthouse. The dance was not held in a typical venue, but in the streets. Hosting dances in the streets has been repeated on other occasions throughout Papillion's history.

As the community marched through time and survived Prohibition, the Great Depression, and numerous wars, it became apparent that a strong sense of community pride always afforded a reason to have fun. When Prohibition hit, the Storz Bar became the Alyce Theater; when the boys went off to war, the community came and marched in the streets with flags and music; and when recently, one did not make it home from Afghanistan, the people of Papillion took time from their busy days and lined the streets saluting, waving flags, crying, and standing in honor of a fallen hero.

Papillion is truly unique, and as time passes by, the bounty of images that captures the true spirit of its people grows. In the early days, locals raced their horses in the street, watched movies on a large sheet draped across the front of the old high school, and danced in the park. Today, citizens enjoy the Twilight Criterium Bike Race, family movies under the stars at the Sumtur Amphitheater, and more dancing in the park. Such activities reveal how Papillion became one of America's best places to live.

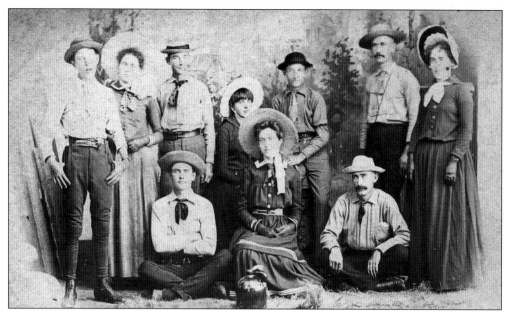

The Papillion Dramatic Club was organized in 1880 with G.H. Ross, stage manager; Dr. W.C. Upjohn, business manager; Edith Shaw, secretary; and J.E. Campbell, treasurer. The opera house performances brought pleasure to the town between traveling shows. Standing on the left are Elmer Clarke and Martha Clarke, and sitting in front of them is I.D. Clarke. (Courtesy of SCHS.)

The men who joined the production of a Womanless Wedding are captured forever in this unforgettable image. Men of all ages joined in the fun in the community production that was likely performed at the high school or in a local hall. It is believed the photograph was taken in the 1960s. (Courtesy of SCHS.)

In May 1918, ten men drafted into World War I assembled in Papillion to catch the train to Camp Funston. The service flag of 100 stars flew at the courthouse where they listened to special speakers and patriot music, after which they enjoyed a roasted chicken dinner at the courthouse Exchange Hotel. With their stomachs satisfied, they followed their commanding officer to the streets to practice drills. Finally, their families joined in the march waving flags and playing instruments in a parade to the depot where they boarded the train. Though the order of the men in picture cannot be verified, they are: Carl Langheine, John Doebken, Edwin Goertz, Earl Petty, Fred Raymond Lamb, Alonzo Griffith, William Condron, Abe Cohan, Arthur Hoover, and Norman Lovell. (Above, courtesy of Jim Miller; below, courtesy of PAHS.)

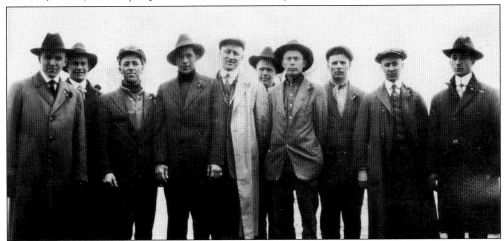

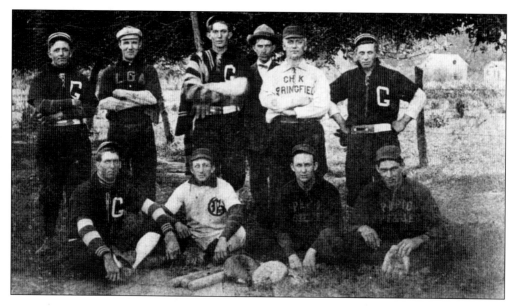

Papillion has a long history in sports, particularly in baseball. This photograph above features the 1908 Papillion semiprofessional baseball team. Those pictured are, from left to right, (first row) Bob Richardson, Gretna; Ira Beadle, Papillion; Bert Bates, Springfield; and Denver Carpenter, Papillion; (second row) "Dad" Quinley, Springfield; Lou Daup, Papillion; Blondy Ruff, Papillion; unidentified; "Tubby" Young, Springfield; and Clayton Beadle, Papillion. The photograph below is of the Papillion 1949 DSC Baseball Championship team. Those pictured are, from left to right, (first row) Paul Klabunde, Harry Cremer, Tate Knapp, Roger Luby, Russ Claussen, and Harold Timm; (second row) batboy Jim Kobler, Gauer Salberg, Gene Snyder, Earl Timm, Wally Borman, Rich Borman, Walter "Sonny" Cordes, Bill Christiansen, Mac Cooke, and manager Don Reis. Not shown are Vince Doll and Wayne Luenenborg. (Above, courtesy of SCHS; below, courtesy of Jim Miller.)

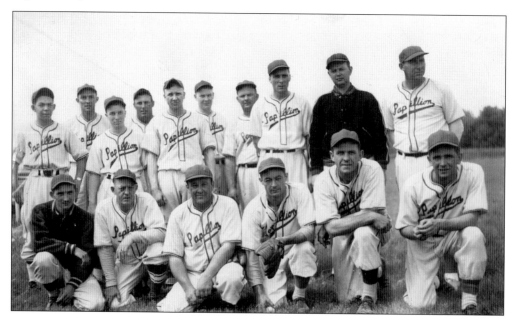

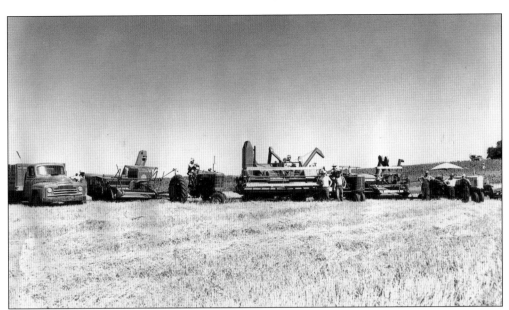

In 1943, the *Papillion Times* reported that several farmers shared a planter, putting in 53 acres of corn in a 24-hour period, an impressive feat in those days. The goodwill of neighbors continued from early pioneer days through many decades, even as the sophistication of machinery improved. (Both, courtesy of SCHS.)

One of the devilish antics of Papillion youths in the first half of the 20th century was to drag an old outhouse into town on Halloween night. Louis Hauschild (left) and Emil Zovodney clean up after a privy was strategically placed in front of the Papillion Police Department. Perhaps the mischievous hooligans should have spent more time with the group of grandmothers below. From left to right are (seated) Irma Whittmuss, Elsie Clark, Frances Stepp, Helene Hyne, Lucy Schobert, Laverna Timm, Georgia Vance, and Anna Mohr; (standing) Hazel Abel, Ida Neely, and Maude Herbert. (Above, courtesy of SCHS; below, courtesy of PAHS.)

E.A. Fricke, second from right, the potentate of the Tangier Shrine, was a member of the Papillion Masonic Lodge No. 39. The Tangier Shrine Circus is a major annual event in Omaha that dates back to the early 1900s. In the photograph, one cannot help but notice to what height he climbed to do his duties as ruler of the Shriners. Circus performers pose dangerously over a busy Omaha Street. Potentate E.A. Fricke stands to the far left in front. (Courtesy of Masonic Lodge No. 39.)

Edgar Howard, former master of Masonic Lodge No. 39, played an important role in Papillion's history. He served as a Sarpy County judge and state representative from Sarpy County before he acquired part interest in the *Papillion Times* in 1883. In 1916, he became lieutenant governor and six years later ran a successful campaign to become a member of Congress until 1934. Howard purchased the Columbus newspaper and died in 1951. (Courtesy of Masonic Lodge No. 39.)

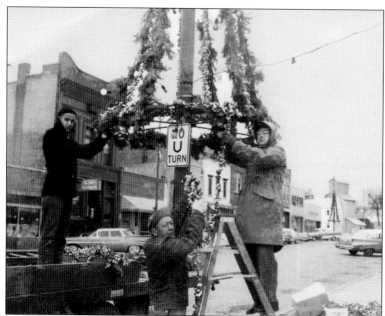

City workers deck the halls with ropes of garland and lights in downtown Papillion in the 1960s. The tradition stands true today, with white lights adorning the trees from the city's downtown center to the intersection of Eighty-fourth Street and Giles Road. (Courtesy of SCHS.)

The Harry Bossard American Legion Post No. 32 hosted a day with Santa at the Papio Theater. It must have been a cold day because Santa, also known as Tony Bucher, was wearing a plaid flannel shirt beneath his jacket. In front is theater operator Elmer Haser, handing out bags of goodies. In the back are, from left to right, Orval Godsey, Don Klingman, and Bob Corn. The little girl is unidentified. (Courtesy of SCHS.)

The City Park was set aside as common land as early as the 1880s and was the site of an annual Old Settlers' Picnic. The Old Settlers' Society began before 1900 and was organized in part by Drs. William C. and Mary Upjohn and was open to anyone who had lived in the area for 25 years or more. (Courtesy of SCHS.)

In 1922, a group of Boy Scouts and their leaders built the Boy Scout Cabin in City Park as a place to hold their meetings. The 89-year-old structure stands proudly in City Park today and is as strong as the Boy Scout organization, which is still active in the community. (Courtesy of SCHS.)

Lyta Bellinger and her horse Twinkles stole the thunder from other rodeo queen contestants in the Papillion Saddle Club's 1959 rodeo. The Saddle Club was popular among young and old and had an arena west of the City Park, where the soccer fields are now located. (Courtesy of SCHS.)

The Papillion Junior Women's Club hosts a kiddie parade in conjunction with the annual Papillion Days celebration. These parade winners are, from left to right, Dean Abels, Mike Hauschild, unidentified, Gene and Paul Huebner, unidentified, Lyta Bellinger (parasol), and Sue and Chuck Ehlers. The mule is believed to have belonged to Blondy Ruff. (Courtesy of Deloris Wittmuss.)

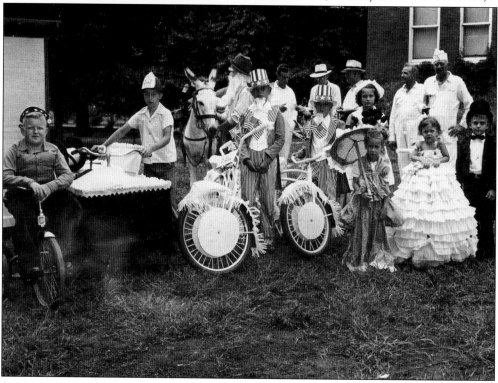

The spirit of the town's early pioneers shines through in this child's float, themed "Papio or Bust!" Children were encouraged to design their own floats that showed their ingenuity and creativity. Even today, the kiddie parade is an important part of the way Papillion celebrates. (Courtesy of PAHS.)

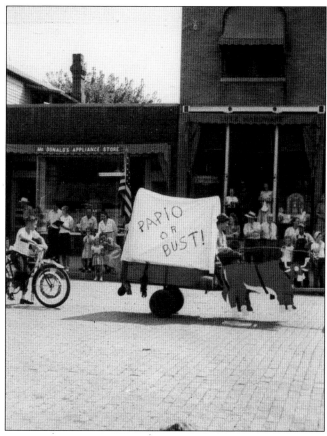

The Papillion Days celebration is a three-day event in the month of June. Each year, merchants, individuals, clubs, and community organizations come out in force to celebrate with parades, mayor's lunch, dances for teenagers, fireman's dance, crafts fairs, and lots of games and rides on the midway. The annual event draws tens of thousands to Papillion each year. (Courtesy of the Papillion Community Foundation.)

The Bell Drugstore was located on the corner of First and Washington Streets where the Eagle's Club is today. Paul and Marguerite Kuhl ran the store, which filled prescriptions and sold over-the-counter drugs as well as general merchandise. Marguerite worked as a pharmacist at the store. (Courtesy of SCHS.)

Ehler's grocery store was a hot spot located on the ground level of Bell's Hall. Many people have reminisced about dancing or roller-skating in the auditorium above the store and stopping to buy a soda at Ehler's on their way home. Those pictured are, from left to right, Millie Ehlers, Ralph Mohr (butcher), and Herman Ehlers. (Courtesy of SCHS.)

Donis Ione Poole married Herbert Ruff in 1951. Donis became popular across the county for her weekly editorial cartoons that ran in the *Papillion Times*. As well as being an artist, she had a keen sense of humor, treating telephone solicitors to her rendition of "Turkey in the Straw" on her violin. (Photograph and jnformation courtesy of Rodney Ruff.)

The Gun Club bought four interurban trolley cars from the city of Omaha, which they used to construct a clubhouse. The large room in the center had a trolley car on each side. One was modeled into a kitchen where, from left to right, Bob Olson, Bob Schuemann, and Bill Beerline cook up a feast for Gun Club members. (Courtesy of Bob Olson and Bill Beerline.)

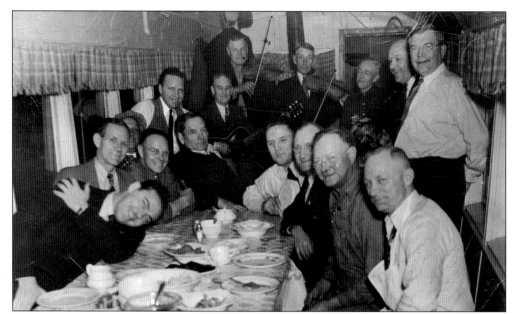

Gun Club members enjoyed a meal and music in one of the interurban cars with special guest *Omaha World-Herald* sportswriter Steve Wulf. Pictured around the table are, from left to right, Steve Wulf, Gus Cordes, Bill Bolling, unidentified, Bill Becker (state game commissioner), Uncle Hank Cordes, Hugo Olderog, Henry Frohsen, unidentified, and Bob Clark. Musicians are, from left to right, Charles Denny, Amos Iske, Ad Graham, Howard Hagen, George Cordes, and Frank Leaders. (Courtesy of Bill Beerline.)

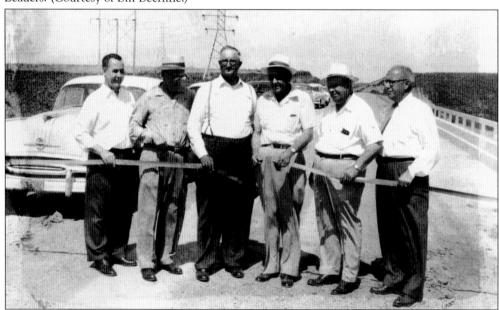

In the late 1960s, the dirt road known as Highway 370 became a paved thoroughfare running east and west from Eighty-fourth Street in Papillion to Gretna and caused an instant boom to the population of Papillion and some surrounding communities. County commissioners are, from left to right, Bob Corn, Otto Timm, Jake Schram, unidentified, Ed Krist, and Robert Clark. (Courtesy of SCHS.)

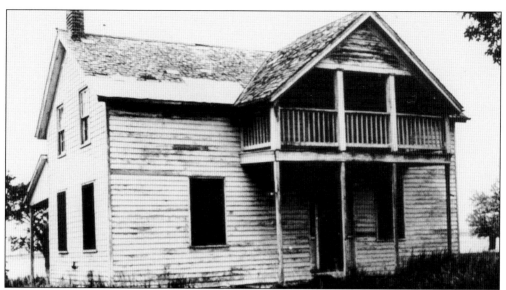

Papillion experienced a boom in population in the 1970s, enticing developers and farmers to strike deals on land to make room for more people. The John and Mary Sautter farmhouse was visibly in the path of destruction in the 1970s, according to Nancy Ryan, who viewed the small German homestead from her kitchen window. The house was saved from demolition in 1979 by the Papillion Area Historical Society and moved to across the street from city hall. Ernie and Lilly Rockenbach, Genny Stephens, Jim Miller, Red and Joyce Timmerman, Herb and Helen Linneman, Walt and Betty Guy, Shirley Ertz, and Mrs. Dennis Smith were a few of those who gave of their time and resources to restore the Civil War–era farmhouse that is uniquely German in its construction. The house is open to the public and in the National Register of Historic Places. In the photograph below is Red Timmerman. In the photograph below, Red Timmerman installs the necessary electricity for the house to be shown as a museum. (Both, courtesy of PAHS.)

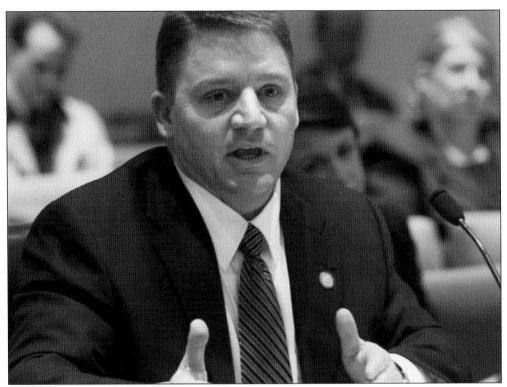

Papillion senator Tim Gay, a chairman of the Committee of Heath and Human Services, led an impressive group of legislators to write LB 603, the Behavioral Health Workforce Act, which transformed the way in which mental health workers are trained to respond to families who are touched by the sometimes crippling effects of depression, substance abuse, schizophrenia, and addictions. Senator Gay was elected to the Nebraska Legislature in 2006. He and his wife, Tonee, live in Papillion with their children, from left to right, Matthew, Katherine, and Nicholas, who are pictured at the Nebraska State Capitol on the day the day of Senator Gay's swearing in. (Both, courtesy of Tonee Gay.)

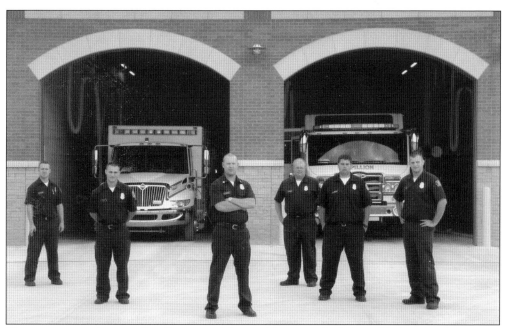

The growing population in Papillion caused the need for career firefighters. To date, the department has 41 firefighters that protect the citizens in more than 61 square miles of Sarpy County. In 2009, the Papillion Fire Department constructed a new building on 108th Street. Those pictured are, from left to right, Matt Sullivan, Bryce Teager, Lt. Chad Jeffers, Todd Remmers, Patrick Comstock, and Nick Gunia. (Photograph by Steve and Bobbi Olson)

In 2005, the Papillion Community Foundation celebrated 135 years of community pride with a butterfly-adorned cake float. The Papillion Community Foundation hosts the annual Papillion Days celebration as well as many other community-related events. (Courtesy of the Papillion Community Foundation.)

The Sump Memorial Library was built in 1995. The library was previously housed on the third floor of city hall and had outgrown its space and was no longer able to fully serve its patrons. It is named after its generous benefactor, Wally Sump. (Photograph by Steve and Bobbi Olson.)

The Dog Days of Summer is a day for furry friends to enjoy a refreshing splash in the pool at Papio Bay Aquatic Park. Papio Bay features a large graded pool with water slides and diving boards. A children's swim area keeps them entertained in a safe, fun, and colorful environment of splashy delight. (Photograph by Steve and Bobbi Olson.)

Many beautiful locations throughout Papillion appeal to brides. The Hoins-Anderson wedding took place in the restored district courtroom of the old courthouse, which is now city hall. Members of the wedding party are seen at right. Wedding photographs of the gardens at the Sump Memorial Library and the Portal School and Sautter House are a lasting impression of then and now. Another location that is gaining wedding popularity is the Sumtur Amphitheater seen below, which is named for its major benefactors, Wally Sump and Wes Turtscher. The amphitheater, the brainchild of Ken Molzer, who worked tirelessly to see it become reality, is a hot spot in Papillion for its live performances as well as twilight movies in the park. (Right, photograph by Carla Portis; below, photograph by Steve and Bobbi Olson.)

Papillion is proud of its Twilight Criterium Bike Race, a USA Cycling–sanctioned bicycle race that goes through downtown Papillion. The excitement grows each year as spectators line the streets to watch professionals try to outrace their opponents to the finish line. (Photograph by Steve and Bobbi Olson.)

In 2007, Papillion and area residents packed the parking lot of the newly constructed Shadow Lake Town Center for a celebratory concert by the B-52s. It was standing room only. By 2010, the shopping center was up to 92 percent occupancy and brings millions of consumers into Papillion each year. (Photograph by Steve and Bobbi Olson.)

The old Portal Schoolhouse, preserved and protected by the Papillion Area Historical Society, stands proudly across the street from city hall. More than 700 fourth-grade students experience a day of instruction in the one-room school to learn the challenges of education during the days of the early pioneers. (Photograph by Brad Williams.)

Over the years, thousands of young people have been confirmed in the faith at St. Paul's. Robert O'Neal, later a judge and the writer of the Introduction of this book, is the second child from the right in the second row. (Courtesy of St. Paul's.)

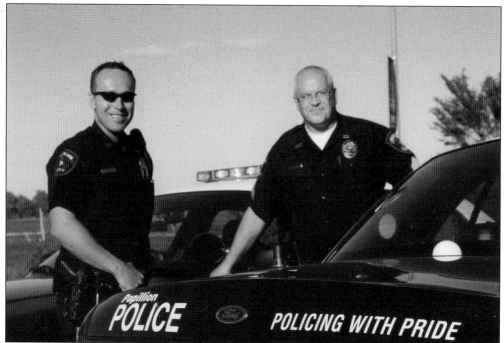

Officers Cory Habrock (left) and Steve "Yogi" Young stand beside a police cruiser. Papillion has a relatively low crime rate and focuses on ways to keep the community safe and educated through programs such as Drug Abuse Resistance Education (DARE) and Gang Resistance Education and Training (GREAT), Neighborhood Watch, and COPPS (Citizen Oriented Police and Problem Solving), where the officers routinely attend functions throughout the community and in the schools in order to better understand the citizens' needs. (Photograph by Steve and Bobbi Olson.)

Fire chief Bill Bowes came to Papillion in 2005 after serving as a battalion chief in the Omaha Fire Department. The Papillion Fire Department has one of the best response rates in the county. (Courtesy of Bill Bowes.)

Papillion has grown, but some of the charm of the old downtown still remains. Looking north from the Lincoln Street pedestrian bridge highlights the impressive city hall, which dates back to 1923. The city hall is in the National Register of Historic Places, having preserved the original mosaic-tile floors and winding staircase. A restoration project in the late 1990s brought back the original beauty of the old district courtroom on the third floor, which now serves as the city council chambers. Antique wooden pews were specifically sought to make the room as close to its original appearance as possible. Most of the old storefronts on Washington Street still operate as businesses, and the sign from the old Papio Theater now reads "The Rock" and is home to the Papio Creek Baptist Church. (Photograph by Brad Williams.)

The people at St. Martha's Church express their fun nature and are an example of the spirit of Papillion. The people are, from left to right, Bishop James Krotz, Lisa Vann, Amber Young,

Harry Hawkins, Kim Newberry, Deacon Nancy Houston, and Fr. Tom Hansen. (Courtesy of St. Martha's.)

# www.arcadiapublishing.com

Discover books about the town where you grew up, the cities where your friends and families live, the town where your parents met, or even that retirement spot you've been dreaming about. Our Web site provides history lovers with exclusive deals, advanced notification about new titles, e-mail alerts of author events, and much more.

**MADE IN THE**

Arcadia Publishing, the leading local history publisher in the United States, is committed to making history accessible and meaningful through publishing books that celebrate and preserve the heritage of America's people and places. Consistent with our mission to preserve history on a local level, this book was printed in South Carolina on American-made paper and manufactured entirely in the United States.

This book carries the accredited Forest Stewardship Council (FSC) label and is printed on 100 percent FSC-certified paper. Products carrying the FSC label are independently certified to assure consumers that they come from forests that are managed to meet the social, economic, and ecological needs of present and future generations.

**FSC**
**Mixed Sources**
Product group from well-managed forests and other controlled sources

Cert no. SW-COC-001530
www.fsc.org
© 1996 Forest Stewardship Council

Find Your Place in History.